IMAGES
of America

MARIPOSA
COUNTY

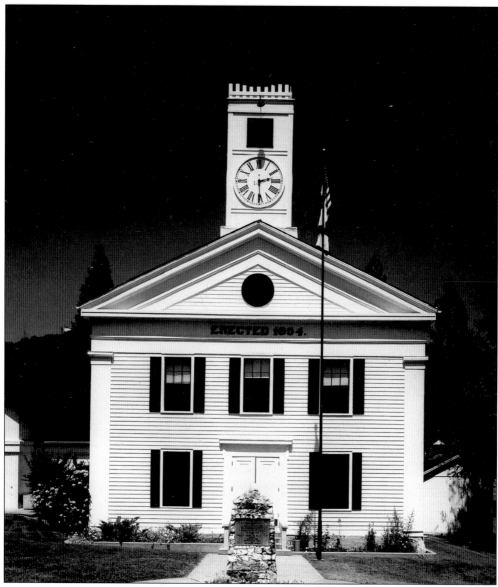

The Mariposa County Courthouse was built in 1854 from locally milled timber joined together by mortise and tenon, with wooden pegs holding the joints. The exterior was applied with square nails. The courthouse has been the seat of justice for Mariposa County longer than any other west of the Rocky Mountains. Cases heard within its walls became the basis for many laws governing the development of the rest of the West, including *Bittle Boggs* v. *Merced Mining Company*. (Courtesy of the author.)

IMAGES
of America

MARIPOSA COUNTY

Leroy Radanovich

ARCADIA

Published by Arcadia Publishing
Charleston SC, Chicago IL, Portsmouth NH, San Francisco CA

Printed in Great Britain

Library of Congress Catalog Card Number: 2005920110

For all general information contact Arcadia Publishing at:
Telephone 843-853-2070
Fax 843-853-0044
E-mail sales@arcadiapublishing.com
For customer service and orders:
Toll-Free 1-888-313-2665

Visit us on the internet at http://www.arcadiapublishing.com

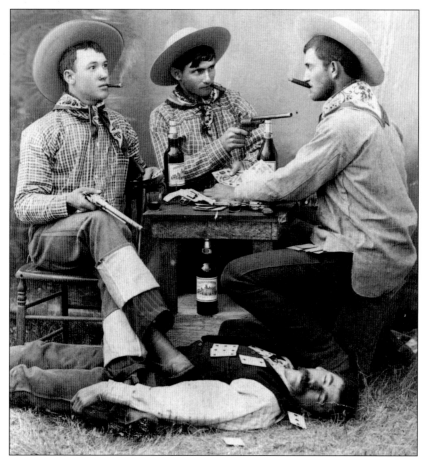

Jack Milburn, left, and the boys have a friendly game of cards. (Courtesy of the author.)

CONTENTS

ACKNOWLEDGMENTS

This volume containing a sampling of the pictorial history of Mariposa County is designed to provide an understanding and appreciation of our beginning and early development as a county. I have had much help in gathering and interpreting the images and stories presented here. Over the past 60 years, many people have seen fit to pass on to me their personal histories—the stories of their lives, their families, and their precious photographs. Perhaps the first to involve me in a significant way was Shirley Sargent, the wonderful Yosemite writer and historian. She invited me to copy the photo collection of Jim and Bessie McElligott.

It was people like Jim and Bessie McElligott who saw fit to preserve through me their colorful lives and our history. Still helping me is my friend Scott Pinkerton. To him I owe a debt of gratitude for all the learning he has exposed me to. As my partner in Mariposa Heritage Press, he provided the knowledge and ability to interview old-timers. Then there is Tom Phillips, my young friend and associate. His tireless research has revealed details that I might have overlooked. He has been of great value as a longtime friend and historian, and the future is in his hands.

Most of all I want to thank the people of Mariposa County for sharing their stories and pictures. It is strange, now that I am over 70 years old, with 61 plus of those years spent in Mariposa County, that I knew well men and women who were born just after the Civil War. For young readers this seems like long ago, but for me it is only a second in time.

Most important is the existence of a fine historical society in the Mariposa Museum and History Center, which has the dedicated involvement of the community. Participants in the historical preservation process create an atmosphere for learning with their dedication. Their new archival vault will be the ultimate repository of all my photographs, negatives, and papers. How fortunate we are to have a forward-looking Mariposa County Board of Supervisors to help finance the project. It will truly be the repository of California history and our place in it.

Central to this book are the photographers. Many are unknown, but one, Carlton E. Watkins of San Francisco, came to Mariposa in 1860 to photograph the assets of Fremont's grant. He used a glass plate camera producing prints from hand-coated glass negatives. He would process his negatives in a dark tent, air-dry them, and pack them away for the trip to San Francisco. There he would make the contact salt prints exposing them in the soft light of a foggy day by the bay. This set of prints was probably the first use of photography for real estate purposes. More importantly, however, this job brought Watkins in contact with Yosemite, where his early photography led to its preservation.

All of the photographs in this edition are either original images created by the author or borrowed from private collections. Photo credit and sources are identified in captions.

The author is aware that many important images have been left out of this volume. Hopefully, subsequent volumes will incorporate more information on other communities of Mariposa County. Information on El Portal and Yosemite Valley may be found in Arcadia's *Yosemite Valley* book. The Merced River area is explored in *Memories of El Portal* by James Law, published by Mariposa Heritage Press. For information on related subjects and books, please contact the author at Radanovich Photography and Historic Galleria, 5018 Bullion Street, Mariposa, CA 95338. Phone (209) 966-5522 or email at radanov@sierratel.com. Mariposa Heritage Press can be reached at PO Box 1966, Mariposa, CA 95338.

At some point in the future, this collection and many others will be available for study at the Mariposa Museum and History Center in their new archival vault.

—Leroy Radanovich

INTRODUCTION

In 1806, a group of Mexican soldiers ventured into the valley of the San Joaquin, via san Juan Bautista and Pacheco Pass. Upon crossing the San Joaquin River, they camped in a ravine containing a small stream. During the course of the afternoon, a sergeant of the troop became engulfed by swarms of butterflies. One of the beautiful winged insects became lodged in the sergeant's ear and had to be removed. The troop's padre, Fr. Pedro Munoz, noted in his journal that, "This place is known as El Arroyo de las Las Mariposas [The Gulch of the Butterflies], because of their abundance."

The subsequent 40 years saw the decline of Mexican fortunes in California. The mission system was abandoned after the revolution displaced the Spanish in Mexico City. This led to the establishment of large ranchos of indeterminate size and questionable boundaries. Seeking one of these ranchos, governor of California Juan Bautista Alvarado petitioned Mexico City. He was granted an approximately 44,000-acre agricultural grant, created for grazing. Alvarado was unable to perfect the requirements of the grant, but nonetheless sold the grant in 1846 to Thomas Larkin, American consul general in Monterey, who was representing Col. and Mrs. John C. Fremont. Fremont was the military governor in California, but he resigned to proceed east to face court-martialling for a conflict between Gen. Stephen Watts Kearny and Cmdr. Robert Stockton during the California portion of the Mexican War of Independence. Returning from Washington, D.C., following the conviction of the court and remission of the sentence by President Polk, Fremont discovered that he owned this Las Mariposas instead of farming land near the Bay Area, as he had told Larkin. Fremont had given Larkin $4,000 to make the purchase for him. Larkin paid Alvarado $3,000 for Fremont's property, pocketing the extra $1,000 as his fee.

The name Mariposa was given to the new county formed in 1850, one of the original 27 and California's largest, covering almost one-fifth of the state. The county seat was at Agua Fria, and in 1851, the county government was moved to the new town of Mariposa. By 1854, the county built a brand new courthouse from local lumber. This courthouse has served our county for 150 years. The town that Fremont wanted was laid out by the banking firm of Palmer Cook and Company of San Francisco. Fremont built an adobe office building for his agents, which still stands in downtown Mariposa. The streets were surveyed to be on a grid, giving proper blocks north-south streets being 60 feet wide, and east/west streets set at 50 feet wide. The north-south streets were named after the Fremont family—Jessie, Charles, Bullion (for Jessie's father, Sen. Thomas Hart Benton of Missouri), and Jones (for Jessie's brother in law). The east-west streets were named Quartz (or First), leading to the Mariposa Mine; then Second through Eighth.

California became part of the United States as the result of the 1848 Treaty of Hidalgo with Mexico, which called for the recognition of existing property , ownerships, and grants. But in Fremont's case, the grant that was purchased for him had a questionable title, as the requirements to perfect the grant had not been satisfied by Alvarado. Fremont applied to the U.S. Land Commission for clear title to his claim, which by this time had floated into the foothill mining region around Mariposa and along the Mariposa River (Creek) and into the San Joaquin Valley. Fremont understood that if he was to have a successful venture, he would need both the mines of the Mother Lode, the agricultural support and water for this project. By 1856, the Supreme Court of the United States directed the state court to restructure the grant boundaries and grant title. Legal issues, both private and public, delayed his full control until 1858. Fremont's title gave him the only private land in the Mother Lode during the Gold Rush.

Other items touched on in this book are the construction of the West's oldest courthouse in

continuous use; the beginning of the publication of California's oldest weekly newspaper, the *Mariposa Gazette*; the growth of Mariposa at the county seat; the important mining areas and mines south of the Merced River, including Bagby and the Yosemite Valley Railroad; and a glimpse into the above-ground facilities in a major gold mine near Hornitos.

While not covered in this volume, Mariposa County is also home to most of Yosemite National Park. Yosemite Valley was first entered and explored by a group of miners from Mariposa who were serving as the Mariposa Battalion. Under the leadership of Col. James Savage, they followed Native Americans who were thought to have killed miners and storekeepers and destroyed their property at various locations. Tracking them led to the discovery of the valley. Within a few years, the first permanent structures were built in Yosemite Valley, with Mariposa being the key dropping-off point for a trip to Yosemite and Wawona. More on this topic is covered in Arcadia's *Yosemite Valley* book.

In 1866, a major fire destroyed 63 wood frame buildings in downtown Mariposa. Rebuilding in brick with iron shutters and sod roofs made Mariposa more fireproof. Small family businesses, logging, and mining supported many Mariposa County citizens, with farming and livestock grazing in the lower elevations of the county continuing to be a consistent, major source of family income.

Since 1950, the development of Yosemite National Park as one of the nation's favorite destinations for families has proven to be the major provider of county revenue and jobs. Strong interest in preservation of the county's scenic and historic assets is consistently a high priority of residents. Those of us who have spent our lives here understand the need to protect the rural nature of our county. Please enjoy this presentation of our history.

—Leroy Radanovich

One
THE BEGINNING

The 40 years between the butterfly in the ear and the purchase in 1846 of a Mexican land grant by Thomas Larking for Col. and Mrs. John Charles Fremont were eventful for California. The revolution in Mexico City and the Spanish departure meant the end of the Mission system in California. Gradually, more Americans came to California—at first for beaver, then for land, and in 1849, for gold. The grasp that Mexico City had on California was slipping away as both internal and external threats were creating difficulties. Texas was threatening to become a republic, and in California, a frontier explorer and army officer named John C. Fremont was leading a number of expeditions to the West through the Rocky Mountains, reportedly looking for better routes west. Each of these trips ended in California, searching for mountain passes and cultivating contacts within the Mexican community as well as the American settlers who relocated there. By 1846, most of the authority of Mexico City had disappeared and was replaced by a system of large land grants creating ranchos owned by native Californians.

Juan Bautista Alvarado, the last Mexican governor of the state, received a 10-square-league (roughly 44,000-acre) land grant that he in turn sold to Thomas Larkin, who was representing John C. Fremont. The land, called "Las Mariposas," was described as west of the Sierra Nevada, between the Chowchilla and Merced Rivers, and east of the San Joaquin. The terms of the grant under Mexican law did not contain the mineral rights; under the Spanish legal system these rights rested with the crown. Fremont made a couple of attempts to set up farming operations on his land, but his agents were driven out for fear of Indian attacks. Upon his return from Washington, D.C., following court marshall, Fremont learned of the discovery of gold in California. Fremont sent his friend Alex Goday, along with a group of Mexican miners he met on his return trip, to Mariposa to begin the search for this precious metal on his land. They did discover gold, first at Agua Fria, and then in the Mariposa Valley. Fremont now had the prospect of untold riches on land that was under United States law.

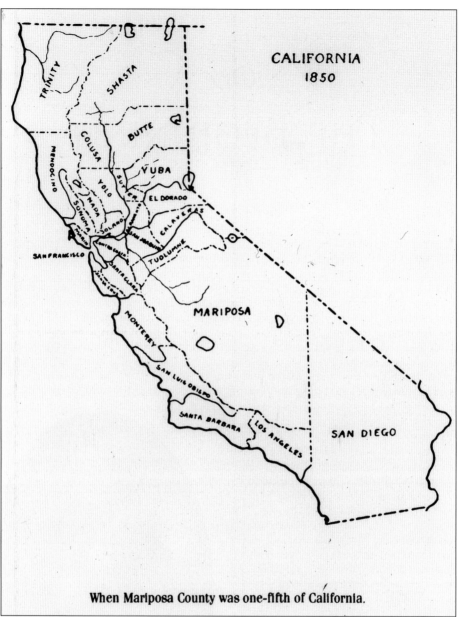

When Mariposa County was one-fifth of California.

Gold was discovered at Sutter's Mill in Coloma, California, on January 24, 1848. The war with Mexico was over, but no treaty had been signed until February 2, 1848, when the United States was granted most of the West, including California. Word did not reach the West Coast until August. Statehood became the first thought of most Californians, but the issue of slavery dogged the attempt. In late 1848 and early 1849, California was divided for the purpose of selecting delegates to a constitutional convention. The task at hand was to create the State of California, elect a legislature, and establish counties. When the legislature finally met, the San Joaquin Division became Mariposa County. This was due to the fact that most of the land in this division was outside of the gold-producing areas, and was either swamp or desert most of the year. When California was finally accepted as a state, Mariposa County was the largest, covering one-fifth of the state.

10

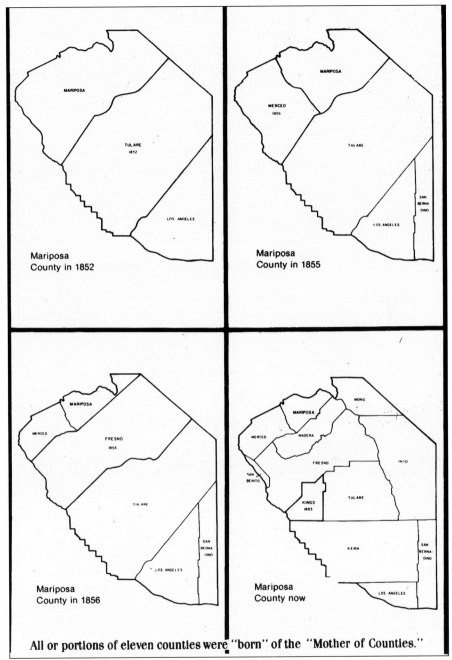

Mariposa
County in 1852

Mariposa
County in 1855

Mariposa
County in 1856

Mariposa
County now

All or portions of eleven counties were "born" of the "Mother of Counties."

Within two years, Mariposa County was divided. First Tulare County was formed. Then Los Angeles was expanded to include the bottom third of the original. In the end, all or part of 11 counties in California were formed from the original Mariposa County. It is interesting that Mariposa, or that part that is known as the mother of California counties, did not object. In fact, when Merced County was formed, there seemed to be great support from the north side, or Coulterville area. That may have been because they wished to split off from Mariposa County, but could not find a partner to increase their land mass sufficiently. There remains, almost to this day, a friendly competition between north and south Mariposa County.

11

LAS MARIPOSAS.

By 1850, Fremont had claim to a poorly defined Mexican land grant. He became one of two Californian senators but did not serve a full term. He turned his attention to legitimizing his claim under American law—including subsurface rights. The Gold Rush took place on federal land throughout the Mother Lode, yet only Fremont seemed to be concerned about getting a clear title. He made application to the U.S. Land Commission, which assigned his claim for title to Las Mariposas as California Land Case Number One. The land commission directed Fremont to engage Allexey W. Von Schmidt, a government surveyor for California, to examine and lay out Fremont's claim. The Von Schmidt map, drawn on linen covered with an emulsion of egg albumen, is now preserved and on display at the California Mining and Mineral Museum at the fairgrounds south of Mariposa on Highway 49. In the restoration process, the linen backing was removed and replaced with an archival substrate. Parts of the map are lost simply due to the drying and flaking of the emulsion. Nonetheless, it is valuable historically because it was part of the first U.S. Land Commission case. The map is also known as the Panhandle Map because the area around Mariposa is shaped like a pan, with the handle following Mariposa Creek (identified as a river on the map) into the eastern edge of the San Joaquin Valley. It was in this portion that Fremont tried to establish his agricultural site in order to perfect the Mexican grant. He also wanted to control the water in Mariposa Creek as much as possible, as water often determines the success of any mining project—either surface water for placer mining or underground water for hard rock mining.

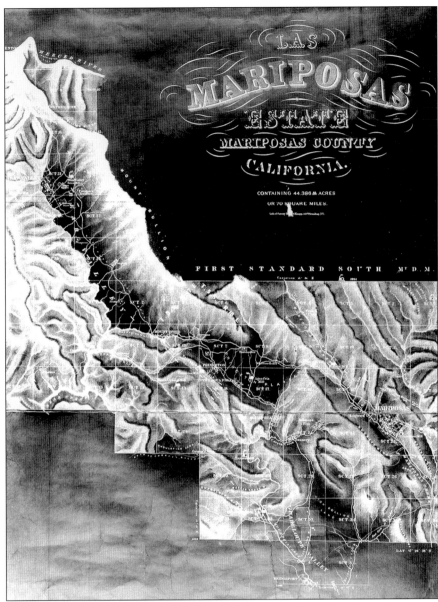

At first, Fremont's claims were rejected, but on March 19, 1855, the U.S. Supreme Court ruled in his favor, ordering the said land to be surveyed in the form and divisions prescribed by law for surveys in California, and in one complete tract. The survey map above was signed by President Pierce on February 19, 1856. The new survey changed the claimed grant boundaries considerably. On the left side of the map, notice that Fremont was given property north of Mt. Bullion (Princeton) to the Merced River. This change included the Mt. Ophir Mine, all of the Placer mines in Bear Valley, and the Josephine, Pine Tree, and Black Drift mines, which were developed principally by the Merced Mining Company. Additionally, the area along Mariposa Creek was removed, effectively ending the grant at Bridgeport. Now the patented land included all of the main formations of the Mother Lode from Merced River to what is considered the end of the Mother Lode, just south of Mariposa. (Courtesy of the Mariposa County Courthouse, Pinkerton and Radanovich.)

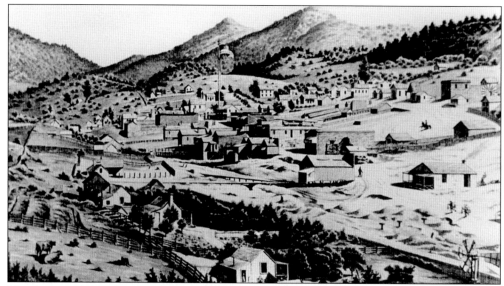

Many investors had created projects on Fremont's land, including the Merced Mining Company. No mining laws had yet been adopted to spell out the proper way for investors to claim property, and the federal government showed little interest in controlling the activities in California. Even the last military governor, Richard B. Mason, found it impossible to control his own troops—he ultimately lost them to the gold fields, gave up, and returned east.

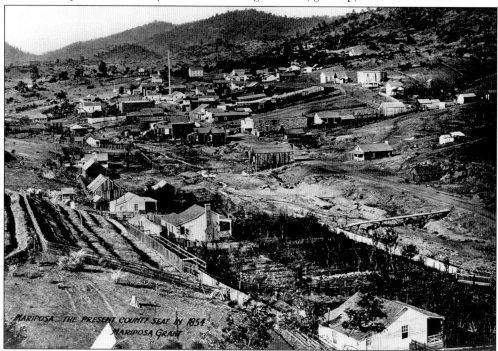

MARIPOSA THE PRESENT COUNTY SEAT in 1854
MARIPOSA GRANT

In late 1849, Fremont leased the Mariposa Valley and mine to the San Francisco investment and banking firm of Palmer Cook and Company. They brought skilled miners, engineers, surveyors, hotel keepers, and faro dealers. The town of Mariposa was laid out on a grid, with 60-foot-wide north-south streets, and 50-foot-wide east-west streets. Many created improvements under leases from Fremont on land he did not own. (Carlton E. Watkins photo, 1860.)

14

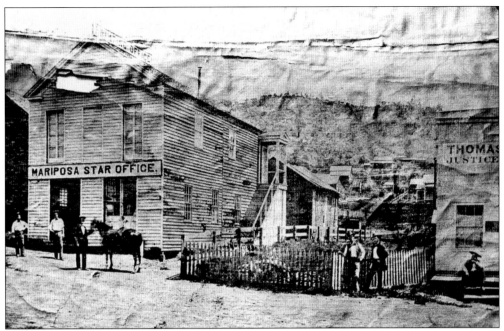

This egg albumin and collodion silver salt print on linen substrate was taken in 1857, and is very likely the first picture taken in Mariposa. The location is Charles Street (Highway 140) north of Sixth Street. Thomas Jay was a justice of the peace for only one year, 1857. In the back is the Schlageter House on Bullion Street, at that time owned by the Thomas Brothers, sash and door makers. (Courtesy of the author.)

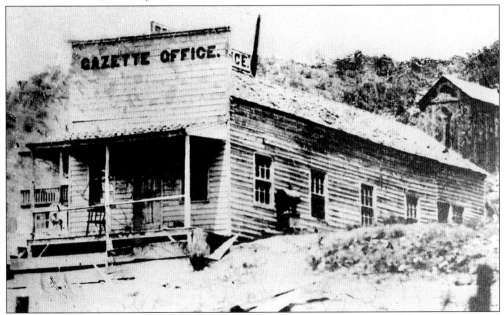

Pictured (from a glass plate negative) is the office of the *Mariposa Gazette* at Sixth and Bullion Streets. The year is unknown, but this building survived the fire of 1866 and the paper continued publishing after the fire. The editor offered the facilities of the *Gazette* to the editor of the *Mariposa Star*, which did not survive the fire.

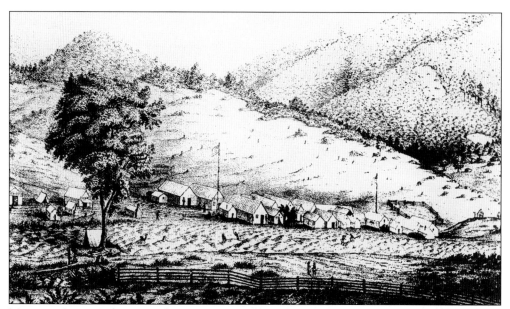

Mariposa County's first seat of justice was Agua Fria ("Frio" in some texts). The responsibility of governing one-fifth of the state was given to tough men in a log cabin along the creek. Any one of the county officials could be called away for weeks to attend to business at faraway locations. It could prove to be dangerous work, as was the case for J.F.A. Marr, county tax collector, who was found dead along Agua Fria Creek, his saddlebags empty.

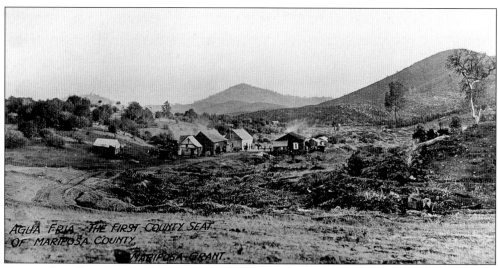

Here is the village of Agua Fria as Watkins photographed it in 1860. By this time, it was no longer the county seat, but was still a significant mining area. Agua Fria Creek continued to be placer mined into the 1930s, while it was still a property of the grant. (Carlton E. Watkins photo, 1860.)

16

By 1851, the interest in placer mining began to wane due to a lack of water to wash a pan of gold. The new town of Mariposa was just a short distance to the east of Agua Fria. On October 13, 1851, notices were sent and the courts directed that, after November 10, 1851, the town of Mariposa would be the county seat. While county government met in many places, a courthouse was planned to open in 1854 or 1855. Architect Perrin V. Fox would design, and Augustus Shriver would build. Tradition says that the lumber was cut at David Clark's mill in Midpines.

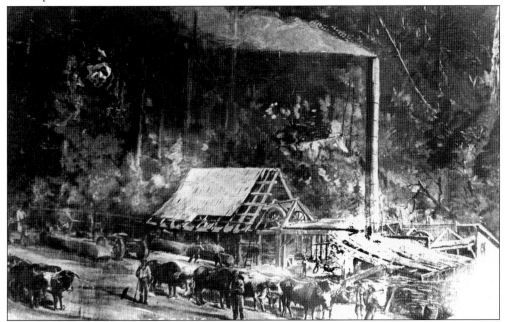

An early artist painted this scene depicting logging and sawing of the lumber for the new courthouse.

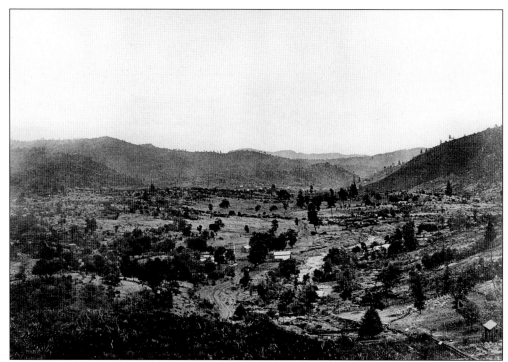

Here is an 1860 view of Mariposa Valley from the north end. While Fremont's claim was being adjudicated, many miners from many nations camped on this claimed land. They mined freely, turning over the creeks and stream banks, leaving piles of rock and earth that can be seen today. By the time of this photo, some subsistence farming augmented the livelihoods of families in Mariposa. (Carlton E. Watkins photo, 1860.)

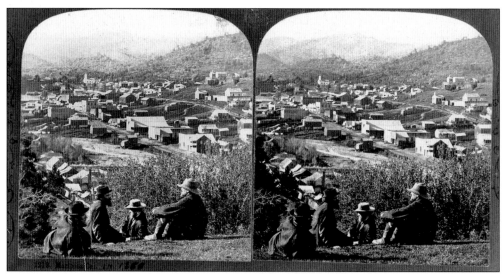

This *c.* 1880 stereo card looks from the west hill shows how Mariposa recovered from the 1866 fire that destroyed 63 structures in the heart of the town. The new Odd Fellow Hall and the Schlageter Hotel are visible. The stereo image was captured by the son of Albert Bierstadt, a Yosemite painter. (Courtesy Yosemite Museum.)

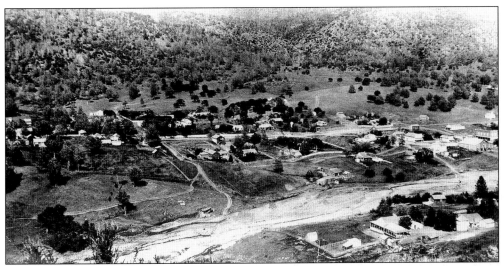

Mariposa's growth and development depended on the viability of the mining properties on the grant. The Mariposa Commercial and Mining Company took over the bankrupt Mariposa Mining Company (the successor to Fremont's operation) and began developing various mining properties. In this 1880s picture, the building at lower right is a county retirement home, also used as a hospital. Bullion Street seems more like a main street than Charles Street.

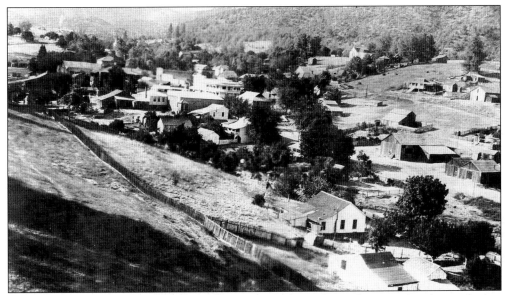

This 1901 image was photographed from the west hill. The verandas were already attached to the Schlageter Hotel. The Bertken Cottage (near the 1858 county jail) had been built from lumber taken from the old Mariposa Methodist Episcopal Church North, which sat 50 feet north of the Bertken property. The lumber of the church was milled in 1852, and showed evidence of mortise and tenon joints, as well as very rough and random one-by planks.

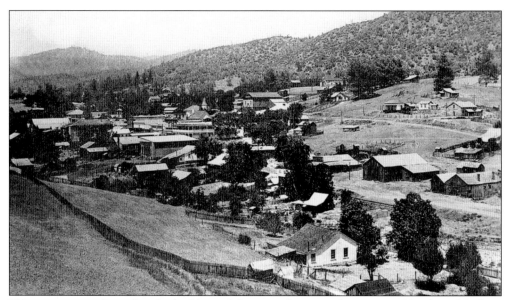

This image was taken after the building of the opera house at the corner of Sixth and Bullion Streets. Also visible is the Presbyterian church and the Larew Building north of the opera house. These three buildings constituted the first high school in Mariposa County. The opera house and Larew Building were destroyed by fire in 1916. School continued in the basement of the church, at the elementary school on Jones Street, and in private homes.

This 1941 image shows the completed Masonic lodge, the Mariposa Theatre, the 1917 high school, and the new grammar school.

Two
MARIPOSA BECOMES
A TOWN

Mariposa was the center of Fremont's efforts to perfect his grant. From the time Larkin purchased it for him until the Supreme Court directed full and clear title to his claim (including mineral rights), most if not all of Fremont's resources were spent trying to gain complete control over what was purported to be a very rich property.

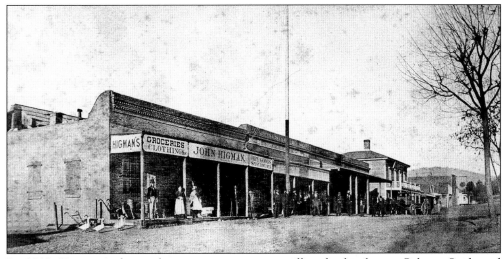

In 1849, Fremont's first task was to construct an office for his lessee, Palmer Cook and Company, and his own agents. The town was yet to be born, but he needed a competent office and lodging for the men who would develop the town. Before California became a state, he built an adobe at the corner of Fifth and Charles Streets, with two spaces up front and three stories of rooms at the rear of the north unit. The roof of this section shows in the c. 1880 picture above. During the 1866 fire, the adobe was damaged by heat. The owner rebuilt the damaged walls on the east and south sides with brick. In this picture, the building is occupied by John Higman's first store. Also visible are the Wells Fargo and post office next door, as well as the Gallison Hotel in the middle of the block. Other tenants of the Fremont adobe over the years included Palmer Cook and Company, and Fremont's agents and lawyers. Other occupants of the space on the left included jeweler Louis Feibush, who owned the building at the time of the fire; Bertken's Butcher Shop; and the Gold Coin Bar, owned by Charlie Greenameyer and Don Turner. Hotels in the space on the right, such as Gordon's, utilized the three-story adobe section until after 1902, when Mariposa merchant John Trabucco purchased the building. Assay and mining equipment engineer James W. Warford occupied the space until the 1940s, with Elijah Phillips being the last mining man in that location. In about 1950, the right side became a pool hall attached to the Gold Coin.

The family history of Horace Meyer suggests that he was a partner or provided the capital for George Bertken to open this butcher shop in 1921. Bertken at times also served as the town constable. Meyer built a slaughterhouse on Stockton Creek northeast of Mariposa and controlled the beef and hog concessions in Yosemite at the hotels as well as the garbage collection. Meyer owned Big Meadow, now part of Yosemite National Park. An icehouse used by Berken is near his cottage on Bullion Street.

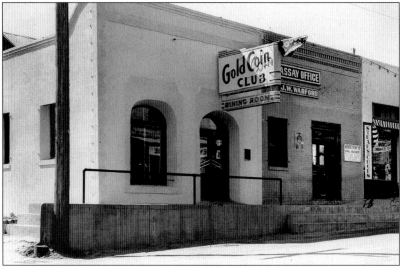

The Gold Coin Club was named after a Merced River gold mine owned by the Greenamyer family. The saloon became a favorite social center in Mariposa. Open card rooms and gambling along with good food made this hot spot successful almost from its opening in 1937. A 1949 fire destroyed the dining and card rooms, as well as much of the saloon's interior. Large murals painted around 1896 by Cornelious Vejer (signed "Con Vega") hung inside. Three of his original paintings remain. Attempts are now under way to preserve the building as a historic site.

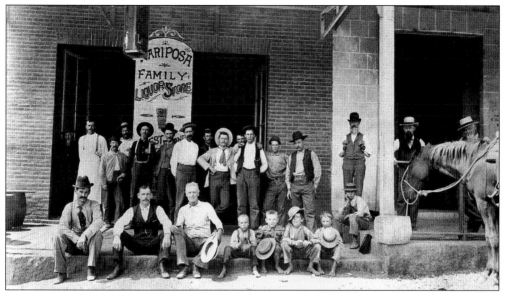

This photo was taken in front of the Mariposa Family Liquour Store, now the south half of the Pizza Factory.

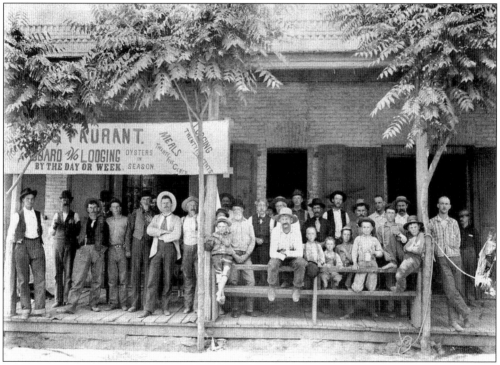

Probably taken the same day as the photo above, this image shows a group gathered in front of the Gordon Hotel (the Fremont adobe, covered by brick after the fire). With rooms at 20¢ and meals at 25¢, Mrs. Gordon was kept busy. Peter Gordon served as the official greeter, cigar seller, and dispenser of fine beverages. His business card said, "Fine Cigars—Fine Liquors." No mention was made of the quality of the accommodations, which were basically cubicles. A section of adobe rooms are still preserved at the rear of the building .

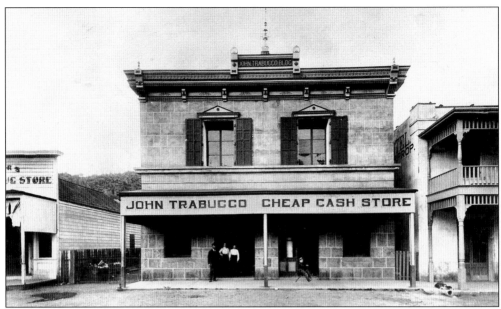

John Trabucco came to Mariposa County from his native Italy in 1862, with his aunt and uncle Louis and Eleanor Trabucco of Bear Valley. As a 19 year old, John first tried his hand at gold mining, but soon realized that raising and selling produce was a more steady activity. In 1892, he married 16-year-old Katherine Razzetto of San Francisco and opened a store in Mariposa. Son Emile was born in the back-room living quarters of the store. A fire convinced John that a fireproof building was in order. He purchased the old Fremont grant granite store building and used materials from the old store to construct the building that became "John Trabucco's Cheap Cash Store," which opened in 1896.

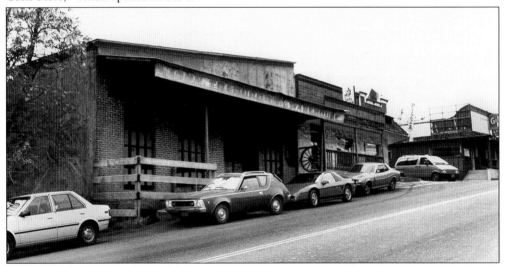

The fireproof building of Mac Dermott and Company, built in 1858, survived the fire of 1866. It became the property of John Trabucco in 1904. He used the upper floor as a warehouse for his main store, and the basement was used to house his brother Victor's horses. Victor ran the wagon train to Merced weekly in order to keep the store stocked. In this building, Trabucco stored lumber, pipe, merchandise, and many other construction and stocking materials for his many ventures.

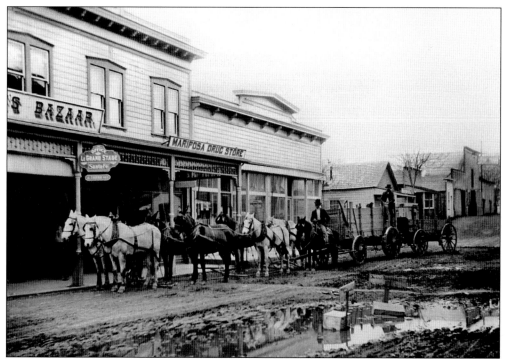

Victor Trabucco was a lifelong bachelor who ran the freight wagons for his brother's growing store. It would take him one long day to go to Merced by way of Mt. Bullion, Old Toll Road, Hornitos, La Paloma Road, and G. Street Grade. The return trip took two days. When reaching a steep section of the road, he would disconnect the second wagon, pulling the first up the hill. Then he would return with the team for the second wagon.

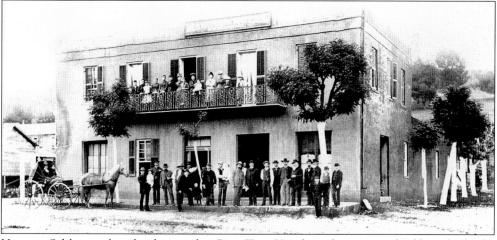

Herman Schlageter bought the wooden Pine Tree Hotel, at the corner of Fifth and Charles Streets, just in time for the 1866 fire. Not discouraged, Herman turned to millionaire miner John Hite for a loan to rebuild the hotel. When first constructed and renamed Schlageter's Mariposa Hotel, the building had a flat roof, probably sod, and a French iron grillwork balcony on the front. By 1901, a porch was added on the front and south side. It is said that a two-lane bowling alley was along the side. The building, still in use as apartments and shops, is a key contributor to the historic district of Mariposa.

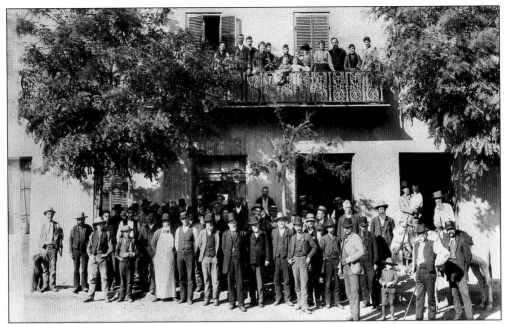

A group of townspeople and guests gather outside the Schlageter Hotel, which continued to operate under the same family name until the mid-1930s.

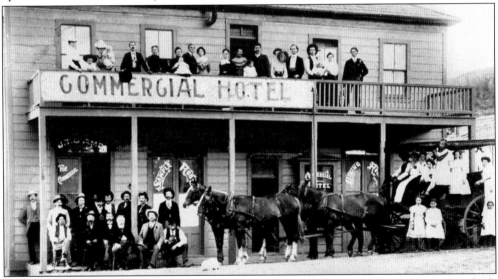

The Commercial Hotel Building sits on the corner of Seventh and Charles Streets. It was built sometime after the fire of 1866 by a man named Artru, whose daughter married Ernest L. Camin. The two of them operated a hotel and saloon, and later a boardinghouse, restaurant, and soda fountain. The Camin family raised vegetables on the lot behind the hotel and installed a gas station on Bullion Street, which became Highway 140 to Yosemite in 1924. They also started Mariposa Auto Court, now Mariposa Lodge. The hotel building was also known as the Camin Hotel, Arlington Hotel, then Schlageters IGA Market. Joe and Ruth Robeson changed the name to Yosemite Market. After the Schlageters, the market was owned by Walter and Myrtle Schultz, Mildred Merrill, the DeCaro family, Enos and Ann Orcutt, Frank DeCaro, and Stan Pierce. It now houses Sierra Stationery.

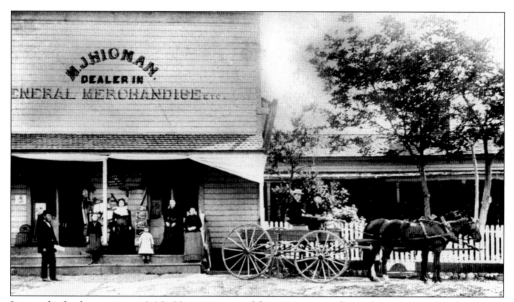

In need of a larger store, M.J. Higman moved his operations from the Fremont adobe to the southeast corner of Seventh and Charles Streets. His daughter Bessie married Walter Farnsworth, a stage driver and one-term sheriff of Mariposa County. The Farnsworth family gained control of this property, which was eventually sold to Everett Bagby.

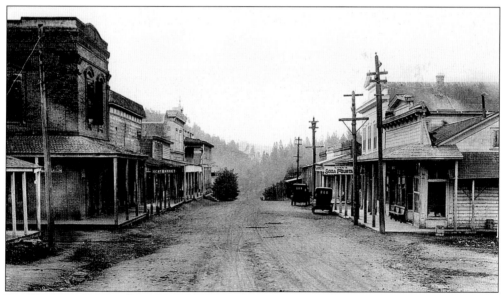

By 1920, Mariposa was becoming a very poor town. The mines had all shut down, and the All-Year Highway to Yosemite (Highway 140) was not finished. The highway construction started in Merced in 1918, did not reach Mariposa until 1924, and took two more years before it connected to El Portal. The opening of this all-weather road to Yosemite Valley brought Mariposa to life again.

Judge Lewis F. Jones and family are pictured at this home on Jones Street. Their lot stretched from Bullion Street to Jones Street. On the lower half was a spring that has provided water for 150 years of gardens and fruit trees. Judge Jones was a county judge serving the district of Mariposa and its surroundings. He had two beautiful and talented daughters, Julia and Lucy, who held positions of responsibility in the community. The Jones home is one of the oldest in Mariposa, and for many years it served the Patrick and J.P. McElligott family.

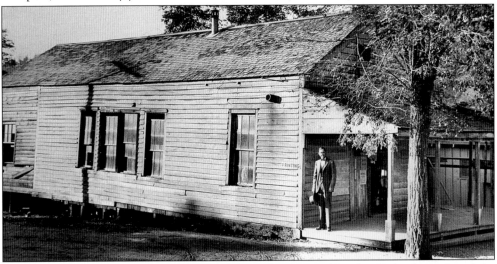

Publisher and editor John Dexter, along with his wife, Kate, and brother Roland, purchased the *Mariposa Gazette* from John Weiler. Dexter, a native of Greeley Hill (in the north of the county east of Coulterville) was a former teacher who served at the time of purchase as the county superindentent of schools. He was married to Katrina Bund and they had two daughters, Marguerite and Kay. Marguerite married Dale Campbell and they had three children: Delmar, Linda, and Dexter. Kay married Ole Olson, and they had no children. Marguerite and her children continued to operate the *Gazette*, along with daughter-in-law Ruth, until August 1997 when Dan Tucker acquired the weekly. In the photo, John Dexter stands on the porch of the old *Gazette* Building, which may have been moved in from Whitlock and was a Knights of Temperance hall. It is presently located at the Mariposa Museum and History Center, has been restored, and the old press is once again printing the news of the week.

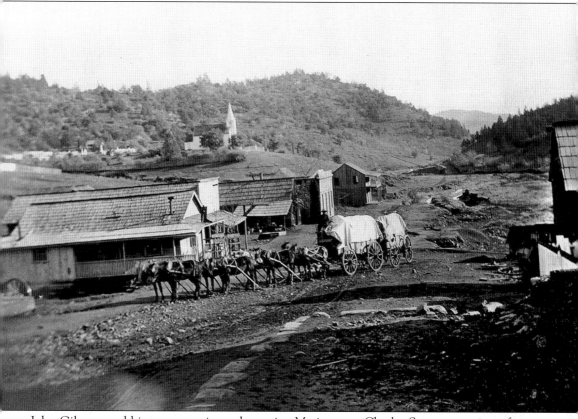

John Gilmore and his team are pictured entering Mariposa on Charles Street, sometime after the 1866 fire. Few buildings can be seen, but foundations of burned-out buildings are evident. The two-story building in the background was on Second or Third Street. St. Josephs Church, built in 1863, can be seen in the background, indicating that it was not affected by the 1866 fire.

Ex-Texas Ranger Angevine Reynolds rode into Mariposa County in 1849 on the back of a white mule. He and his partners searched for gold at Chicken Gulch, just south of Mariposa. An early village called Log Town was raised in the area, but a flooding Mariposa Creek washed away the crude housing. To prevent more catastrophes, the miners moved farther up Mariposa Creek to the present site of the town of Mariposa. Tiring of mining and seeking other opportunities, Reynolds found a partner and began a freight company that would bring supplies and mail from Stockton to the mines. The erstwhile mule was also a partner in the operation. After four years, Reynolds left the express business and returned to Mariposa for the remainder of his life. He became a deputy county clerk, then county clerk, for a total of 14 years. In 1874, he purchased the *Gazette* and was admitted to the bar.

For the next 14 years, Reynolds' *Gazette* was a literary gem. He was well respected by his fellow 49ers and could call on them to write of their experiences in the gold fields. Men like John Hite and Capt. John Diltz wrote lengthy pieces from firsthand knowledge. Researchers today applaud the foresight that Reynolds had to collect these stories. N.D. Chamberlain wrote *The Call of Gold: True Tales on the Gold Road to Yosemite*, long considered a valuable source for the history of Mariposa County. Written in 1937, many of the facts in the book have been clarified with time, but it remains one of the best collections of stories relating to Gold Rush lore. While Reynolds had been dead for many years when Chamberlain was gathering the collection, much of the material used had been developed by Reynolds during his tour as editor.

Reynolds had two wives. The first, Virginia, bore him at least 13 children. Many of them died early of one disease or another. At age 37, Virginia also died in childbirth. She and her baby are buried together in the Mariposa Odd Fellows Cemetery, as are the other children and Angevine. Angevine's second wife, Francis, introduced herself with a letter to the editor (him). They had no children. Angevine died in 1888, leaving the paper to Francis, who sold it to John F. and Thomas Harris.

Three
MARIPOSA COUNTY COURTHOUSE

The Mariposa County Courthouse has been the area's center of activity for roughly 150 years. Many of the officials who have served the county over the years were members of pioneer families. Judge Joseph J. Trabucco, who served nearly 35 years, was the son of pioneer merchants Louis and Eleanor Trabucco of Bear Valley. Many other Mariposa citizens saw it as their grateful duty to be part of county government, if only for one or two terms.

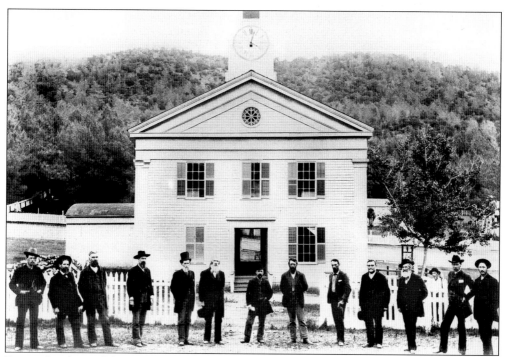

Pictured in front of the courthouse after the 1884 and before the 1891 vault are county officials, from left to right, Fred Schlageter, William Turner, Joseph Ridgeway, Ed Skelton, Judge John Corcoran, Judge Lewis F. Jones, Samuel Counts, George Temple, Gus Robinson, Maurice Newman, James H. Lawrence, Newman Jones, and Henry Farnsworth.

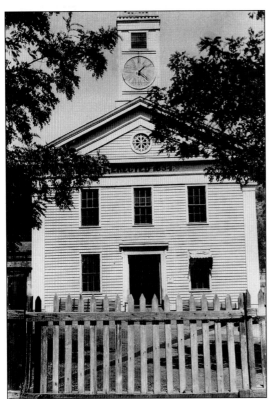

The courthouse is pictured in the late 19th century. Note the absence of shutters, which were often removed at the whim of the board of supervisors.

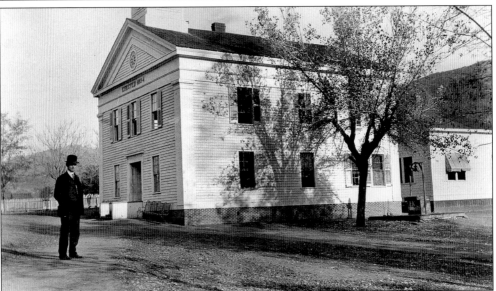

Note the annex in this c. 1900 photo. The breezeway between the two buildings gave those in the offices and employees a spot to have a break and perhaps eat watermelon. All county government, including the schools, was housed in these buildings. The single chimney was for a large stove in the county clerk's office. Heat from the stove was piped into the other offices. Electricity did not come to the courthouse until after 1903. Cooling was provided by hand fans and open windows.

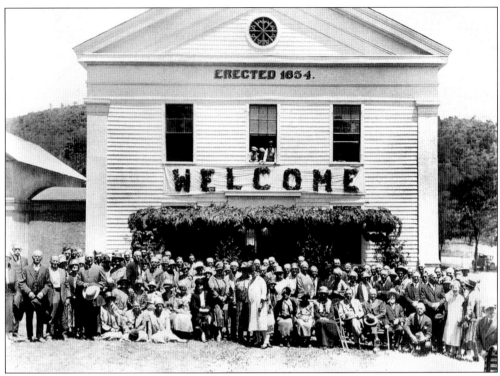

The courthouse was decorated to welcome home the boys from World War I.

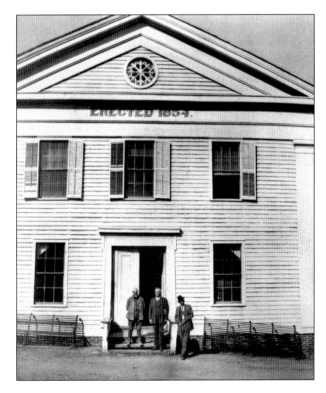

Pictured in front of the courthouse July 5, 1919, are Eugene Daney; Hon. J.J. Trabucco, Superior Court judge; and attorney Richard B. Stolder. Notice the staircase in the right front window leading from the district attorney's office to the courtroom upstairs.

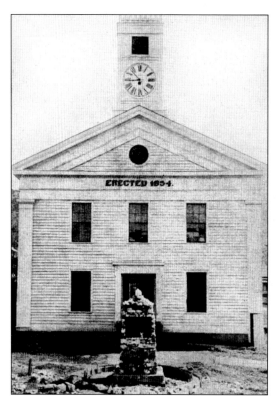

In 1929, a monument to the pioneers was constructed by the Native Sons of the Golden West, Merced Chapter. The finishing of the monument was occasion for a grand celebration.

Judge J.J. Trabucco gives the keynote address at the dedication of the monument to the pioneers. Pathe News documented the event. In addition, Pathe News was taken on a tour of the historic towns of Mariposa County, including Mt. Bullion, Bear Valley, Coulterville, and Hornitos. Many of the old-timers in those towns who could not make the trip to Mariposa came into the street to be filmed.

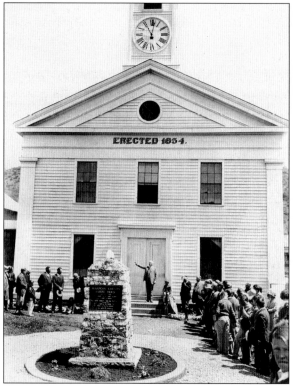

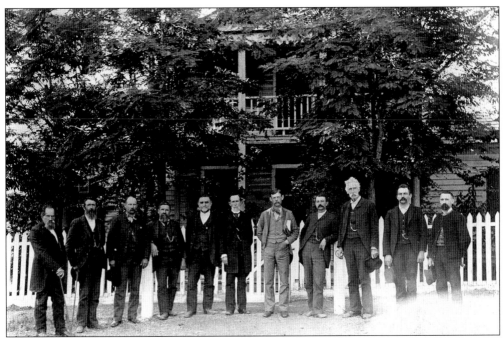

Standing in front of the home of the first Superior Court judge, John M. Corcoran, from left to right, are B.O. Marrs, George W. Temple, Charles A. Schlageter, William T. Turner, Maurice Newman, John M. Corcoran, Fred W. Schlageter, R.B. Stolder, Joseph Stearnes, J.J. Trabucco, and Sam Counts.

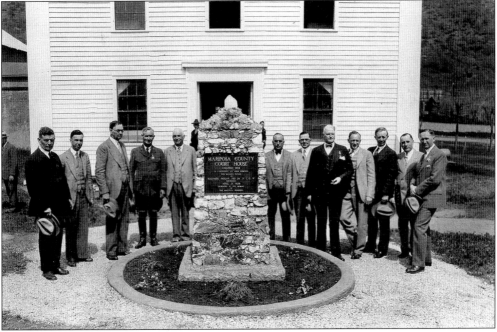

This group of dignitaries poses with the new monument for the 1929 dedication. The identifiable locals, from left to right, are Martin Starns (fourth), Judge J.J. Trabucco (fifth), John Castagnetto (sixth), Louis Milburn (ninth), and A.J. Raynor (eleventh).

stamped their characters on the progress of the world In this connection we quote from an article by Hon. John M. Corcoran published in the Midwinter edition of the Merced *Sun* in 1893. Judge Corcoran has been

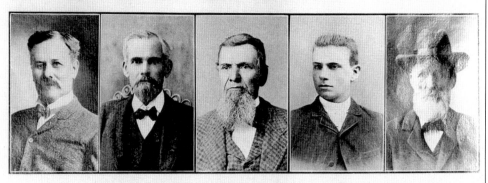

Board of Supervisors.

1. H. W. Cornett 2. W. M. Eubanks 3. Isaac Lyons 4. J. W. Collins 5. James Lindsey

past ten years. He is a native of Massachusetts and a veteran of the Army of the Potomac. Since the close of the war he has been a Californian. The County

a citizen of Mariposa for nearly fifty years. He was County Judge from January, 1872, to January, 1880, and superior Judge (which office was created by the new

Pulled from a board of supervisors pamphlet, these two collages showing local officials were taken by Merced photographer F.A. Judkins, the husband of Alice Weston, a Mariposa girl.

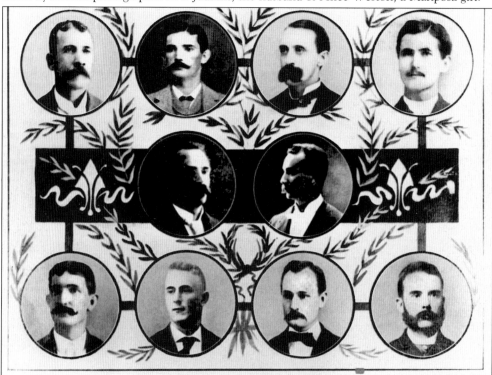

Mariposa County Officials.

1. R. A. Prouty, Sheriff.
7. C. P. Pratt, Assessor.
 2. W. E. Gallison, County Clerk.
 5. J. J. Trabucco, Superior Judge.
 8. W. S. Farnsworth, Tax Collector.

4. F. A. Bondshu, Auditor and Recorder
10. S. J. Harris, Surveyor.
3. S. P. O. Counts, Treasurer.
6. J. A. Adair, District Attorney.
9. D. E. Bertken, Coroner and Public Administrator

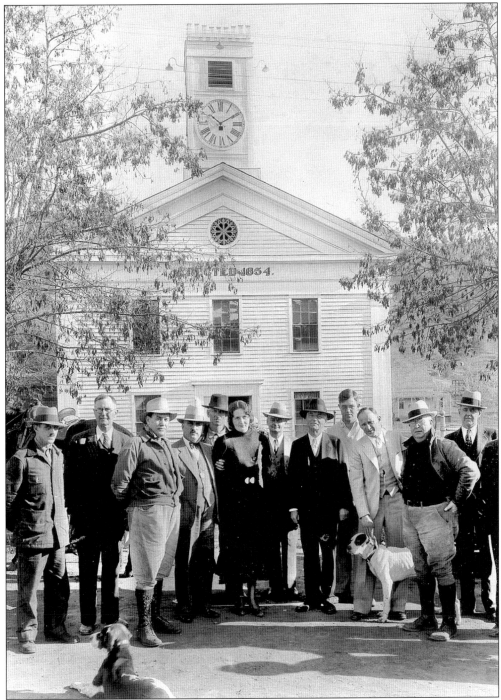

This gathering at the courthouse during the mid- to late 1930s may correspond with the release of N.D. Chamberlain's book, *The Call of Gold*. Dignitaries included, from left to right, Sheriff John Castagnetto (fourth), Marguerite Dexter Campbell (sixth), Kenneth Arndke (ninth), District Attorney Louis Milburn and his hunting dog (tenth), author N.D. Chamberlain (eleventh), and John Dexter, publisher of the *Gazette*.

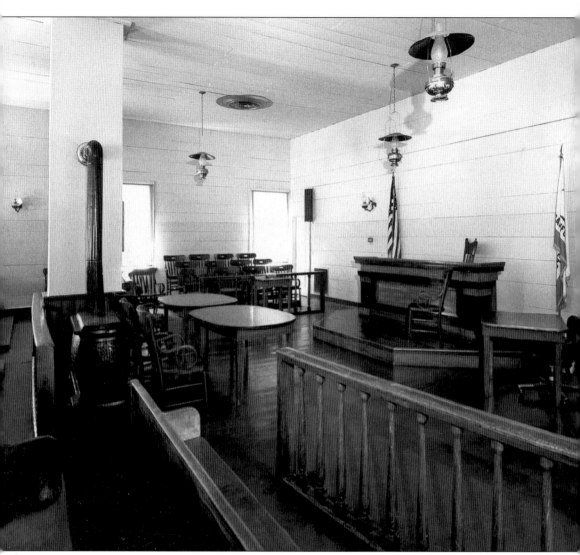

This image of the courtroom of the Mariposa County Courthouse shows the long bench that was built to accommodate the three-member Court of Sessions, which governed both the civil and criminal affairs of Mariposa County until the board of supervisors was formed. The interior has remained essentially the same since the courthouse was built in 1854. The wall planking is hand hewn, and the fixtures, tables, and benches are handmade and finished. The chimney is from the clerk's office. During the 1954 centennial, Mariposa Superior Court judge Thomas Coakley invited counties that had been created in part or whole from Mariposa County to contribute artifacts from their counties to the courtroom. (Courtesy of the author.)

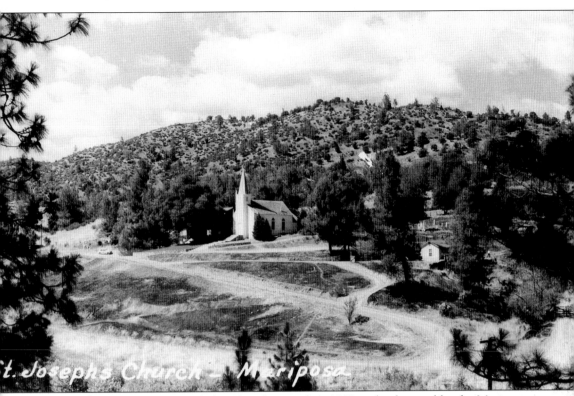

St. Josephs Church - Mariposa

Construction of St. Josephs Catholic Church started in 1862 on land owned by the Mariposa Mine. Alex Deering and R.S. Miller, owners of the mine, donated the property to the church on January 16, 1863, two days before it was dedicated by Archbishop Joseph Sadoc Alemany. At the time of the dedication, the Fremont grant was owned by the Mariposa Mining Company, which was facing bankruptcy. Deering and Miller probably had a lease for the mine property, as they were clearly not the owners. On September 25, 1941, a new deed was obtained by the diocese from the Mariposa Commercial and Mining Company. At that time, the Grant Company, as it was also known, was disposing of its holdings in Mariposa County. More than once over the years, new deeds were drafted to create legal titles to property that had been thought to have been gifts or sold by people who clearly did not have a title. The Mariposa County Courthouse had been constructed on land thought to have been a gift. It was discovered when Fremont sold the grant that it was quite possible that it was not a legal gift, and thus when contacted, Fremont gave the title to the land to the county for the sum of $1.

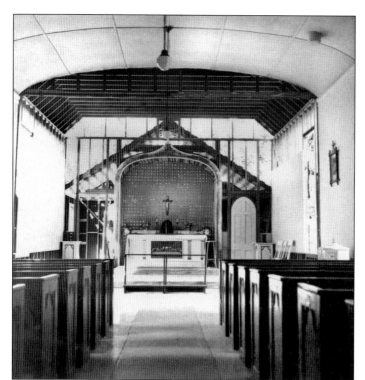

The church had served the community of Mariposa for almost 100 years. In 1958, Fr. Francis E. Walsh, longtime pastor, and the parishioners decided to lengthen the church enough to accommodate 50 more seats. That meant adding 18 feet. The building was separated just in front of the building, and the rear section was moved east enough to accommodate the addition. The original church had three windows on each side, and now there were four.

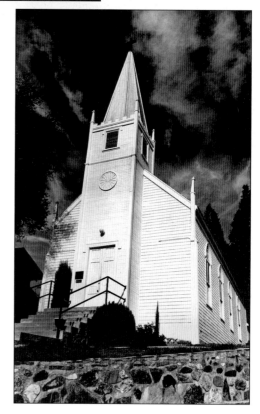

St. Josephs Church is pictured in the late 1970s, after the addition and restoration.

St. Josephs Church is pictured after the restoration. Note its relationship to the Mariposa Mine, from whence the property for the church came. The mill building pictured featured a modern adaptation of mining equipment during a 1950s reopening of the mine. Even though the mine was de-watered, the costs of modern mining were too much for the operator, and the effort was abandoned around 1963.

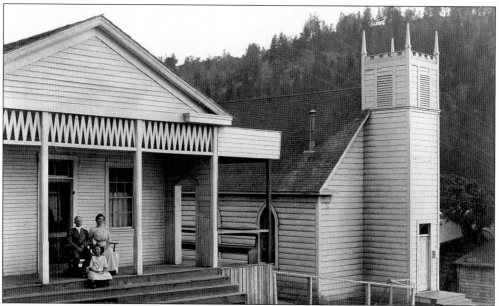

The Methodist Church has the longest history of continued use in Mariposa. The first church was the Mariposa Methodist-Episcopalian Church North, which in 1852 was located on the northeast corner of Fifth and Bullion. Disagreements within the congregation caused a split in the group, causing the building of the Mariposa Methodist-Episcopalian Church South, located sometime later on Charles Street between Fourth and Fifth Streets. That church burned in the fire of 1866, suffering a reported loss of $1,000. During the 1880s, this church, referred to as the Messpah Chapel of the Methodist Church, was built on Sixth Street, between Charles and Bullion. The building to the left was the parsonage, although it was built much earlier. The chapel served the Methodist community until the 1970s, when it was moved to Fifth Street to serve as the Christian Science Church. A new chapel was built on the corner of Sixth and Bullion to replace the old parsonage and the chapel.

The 1852 chapel on Bullion Street fell into disuse, and the structure was purchased by George Bertken. He dismantled the old building in 1899 and used the lumber that had been milled before 1852 to construct a home for his family roughly 50 feet south of the old church. Many of the timbers used in the post and beam construction show the mortise and tenon construction of the church, much the same as the courthouse. This house has been restored, and is currently occupied by the author.

Four

MINING ON THE FREMONT GRANT

It was the lure of gold that started Mariposa County. In spite of the claims by Colonel Fremont, many miners came to the area looking for the pot at the end of the rainbow. Probably because most knew that Fremont did not have a legal claim to the land and its wealth . . . and that wherever else they prospected on the Mother Lode the land, water, timber, and gold were for the taking. Little attention was paid to a floating Mexican land grant. Fremont was powerless to prevent most of the placer mining on the surface and in the creeks. He concentrated on what he believed to be his rainbow—underground quartz vein mining. This took plenty of capital, men, and equipment. Although water was necessary to run the mill, the amount needed was far less. By 1850, the lack of surface water sources slowed placer mining, and industrial mining began.

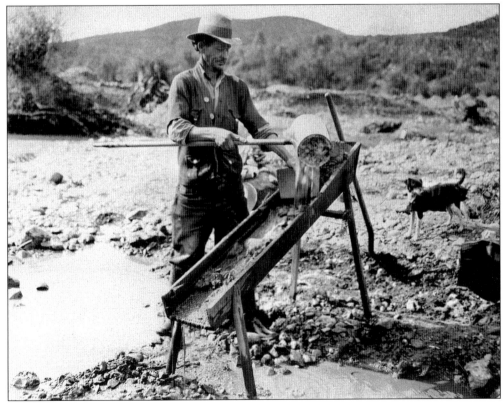

Pictured is a placer miner using a long tom.

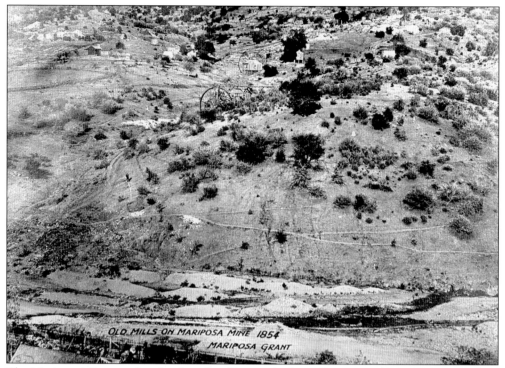

OLD MILLS ON MARIPOSA MINE 1854
MARIPOSA GRANT

The Mariposa Mine was first developed on Fremont's claim. Experienced Mexican miners from Sonora, Mexico, crossed paths with Fremont when he returned from the east after being court marshalled. Fremont struck a deal with them, who had come first to Agua Fria, then to the Mariposa Valley in 1849, and found a large quantity of gold bearing quartz exposed on the hill side, called float. They ground the quartz in arastas along Mariposa Creek (pictured at bottom), separated the gold, took Fremont's share to him in Monterey, and ultimately returned to Mexico. They first identified the vein that was the source of the gold, and thus the beginning of the Mariposa Mine, which Fremont would lease to Palmer Cook and Company.

Many of the photographs in this section were taken in 1860 by San Francisco photographer Carlton Emmons Watkins. The date 1854 may appear on some photographs, but was actually added in error many years later when the original prints were copied. All of Watkins' original negatives and many prints were destroyed in the San Francisco earthquake and fire of 1906.

Vermont's Trenor Park partnered with Fremont by buying some of Fremont's delinquent San Francisco banknotes. Park then hired Watkins to photograph the assets of the grant to raise capital or sell the property. Fremont then had clear title to the grant property and could legally sell. Watkins had come to California with his friend Colis P. Huntington, for whom he worked in a store in Sacramento. Floods caused by hydraulic mining in the mountains sent a torrent of mud and water down the American River, burying Sacramento. An unemployed Watkins went to San Francisco and became an assistant at a photo studio. He quickly learned and mastered the craft. Park contacted him and brought him to Mariposa. They picnicked in Yosemite, and Watkins was taken by the beauty of the valley. He returned in 1861 to photograph it.

Although the Gold Rush was over by 1860, industrial mining was peaking. Fueled by foreign investment, properties in Fremont's grant were all up and running. Most of the mines were in the hands of lessees and not always profitable. Watkins' publicity photos worked, and the grant was sold to New York investors, who sent Frederick Law Ohlmstead (the architect of New York's Central Park) to the Mariposa grant to operate the property. Ohlmstead soon learned that Fremont had not paid his debts. Local goods and machinery were thus not available to him, the new owners refused to pay the debts, and the properties ultimately went into bankruptcy.

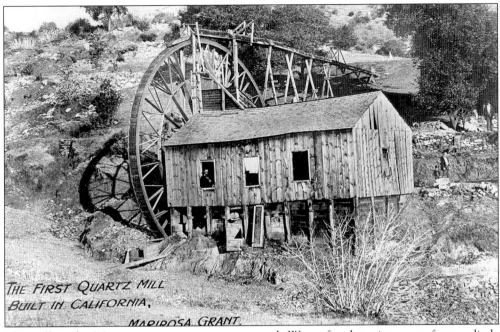

THE FIRST QUARTZ MILL
BUILT IN CALIFORNIA,
MARIPOSA GRANT.

The mill at the Mariposa mine was water powered. Water for the mine came from a ditch originating on upper Stockton Creek. Because early quartz vein mining was required in Mariposa County due to a lack of water for placer mining, this mill became the first such hard rock mill in California. The figure in the window appears in many of these mining pictures and is an attempt to place Colonel Fremont at these sites for promotional purposes. Research, however, places Fremont elsewhere in 1860. (Carlton E. Watkins photo, 1860.)

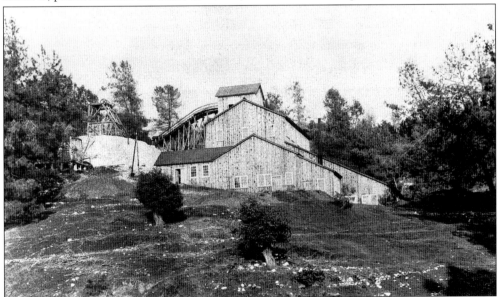

The Mariposa Mine mill building experienced its most productive period between 1890 and 1913. Almost every family in Mariposa was somehow connected to the operation. Capital for the Mariposa Commercial and Mining Company came from English investors, for the most part. Fire destroyed the mill in 1913.

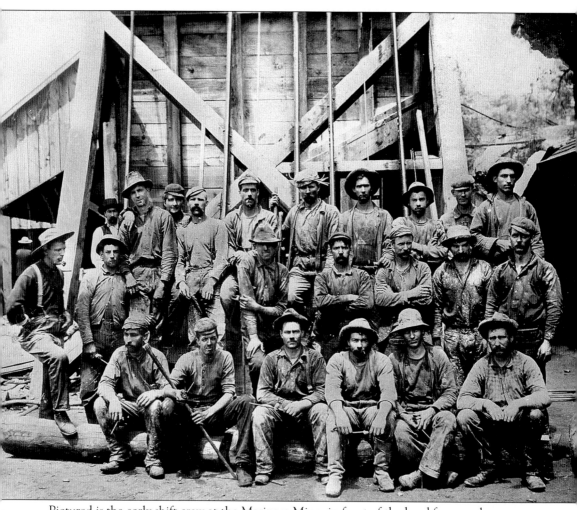

Pictured is the early shift crew at the Mariposa Mine, in front of the head frame—the structure over the main shaft that supports the lowering and raising of ore buckets and miners.

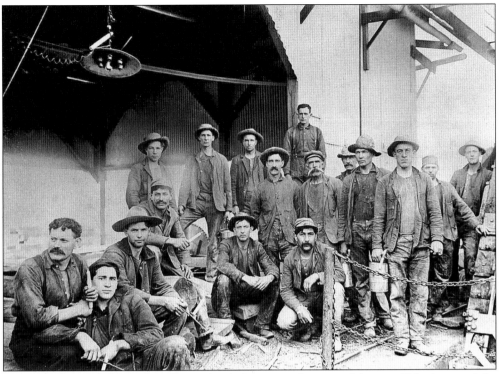

Note the electric light in this photo of a shift crew at the mine. Miners still had to work by candlelight, but electricity from Bagby was used to run the mill and light the yard by around 1903.

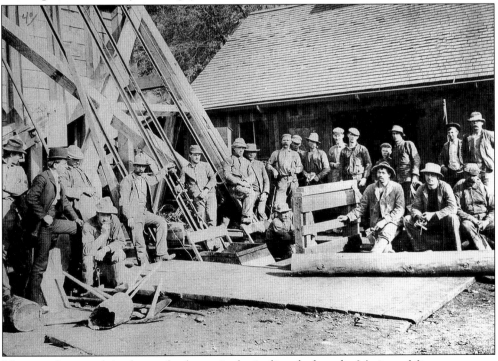

Miners rode to work in the ore buckets, via the incline shaft at the Mariposa Mine.

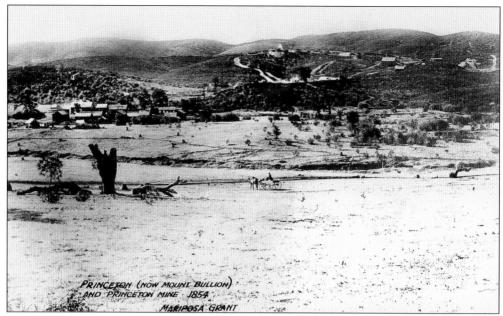

Once called Princeton, after Prince Steptoe, Mt. Bullion changed its name when a post office of the same name came into existence. The new name came from the mountain that rose out of the valley to the east. The main reason for the existence of the town was the Princeton Mine, developed on the Fremont grant. The Mt. Ophir Mine, just a short distance to the north, was developed by the Merced Mining Company. (Carlton E. Watkins photo, 1860.)

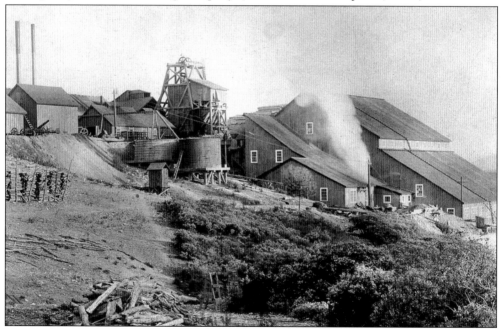

The Princeton Mine was the largest single producing property in Mariposa County. It produced over $5 million (in 1880 dollars) in bullion. No estimate is available as to the value of gold that may have escaped either by inefficient separation or high grading (in pant cuffs). (Carlton E. Watkins photo, 1860.)

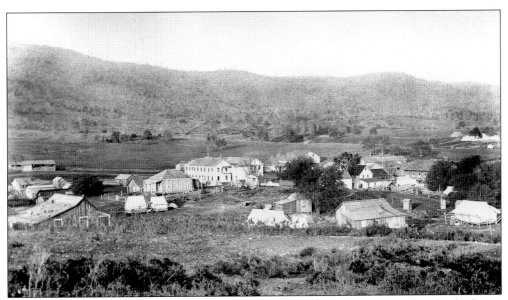

The town of Mt. Bullion is pictured during busy times. In the center is the hotel, which was really more of a dormitory for men working at the Princeton Mine. Many families lived in Mt. Bullion, and in many ways it was a busier town than Mariposa. Mt. Bullion had its own newspaper, dancehall, and elementary school for children of the miners. Civic events crowded the calendar.

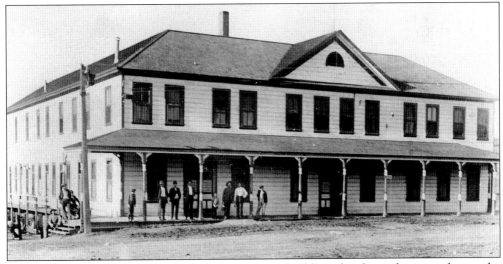

The Mt. Bullion Hotel was a U-shaped, two-story building that housed miners during the town's boom days. Offerings included maid service, electricity (which was provided by the mining company), and meals served for each mining shift. The hotel closed and was demolished soon after the mine closed.

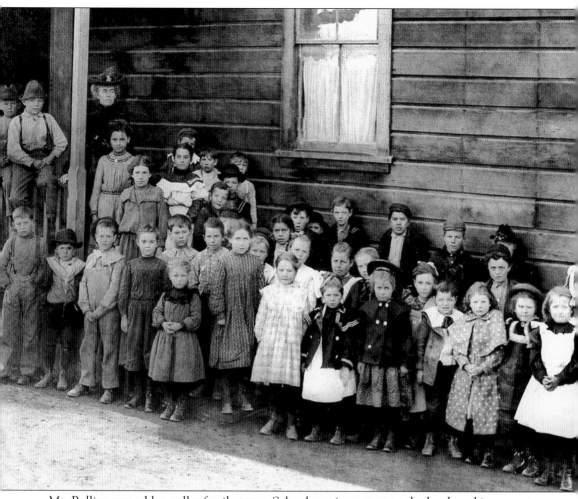

Mt. Bullion was a blue-collar family town. School was important to the hard-working parents. The schoolhouse still stands along Highway 49.

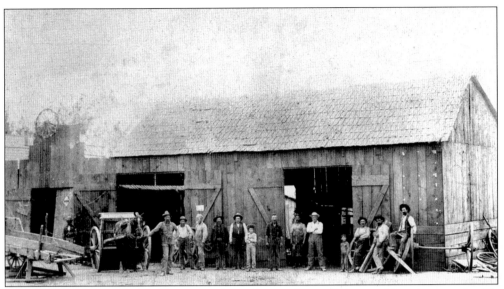

The Mt. Bullion Blacksmith Shop was a busy place and provided everything necessary for life in a mining town, including mining machinery, wagon wheels, horse and mule shoes, and wagon repair.

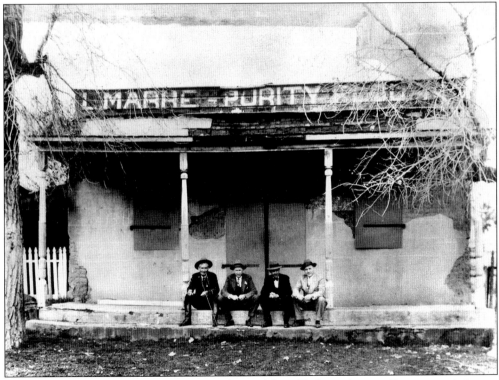

The Marre store in Mt. Bullion was across the road from Trabucco's store. Dignitaries sitting on the steps of the closed store in 1929 were participants in the pioneer monument dedication at the courthouse in Mariposa.

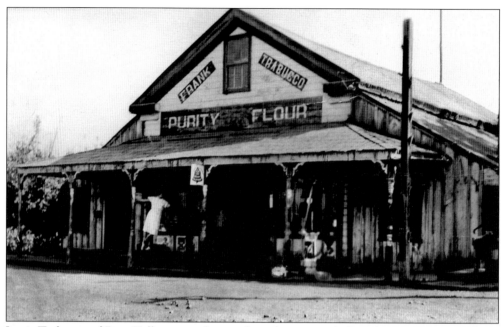

Louis Trabucco of Bear Valley opened a number of stores, including this one in Mt. Bullion. His son Frank ran the store, which stayed in the family until the 1930s.

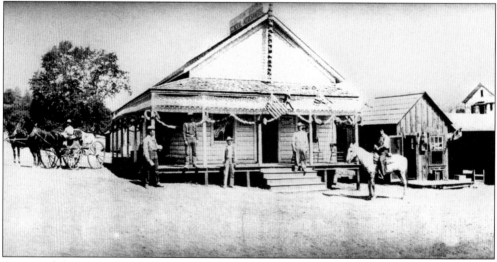

Decorated for a parade, these Mt. Bullion businesses include a saddle and harness shop, a butcher shop, and a post office.

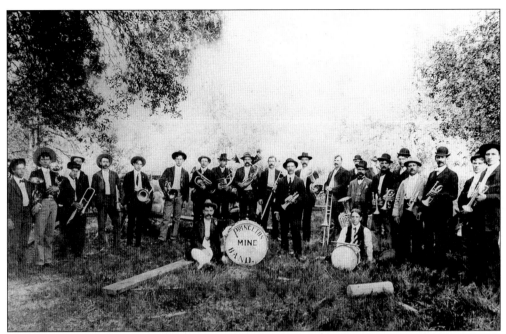

The Princeton Mine Band, known far and wide, was a product of the company offering entertainment for their men. Dances and parties were frequent. The same program existed in Mariposa, where the Mariposa and Commercial Mining Company also had the Mariposa Mine.

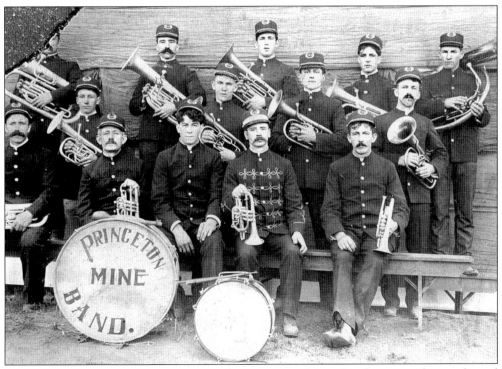

For more formal or smaller occasions, the Princeton Mine Band presented a uniformed brass unit.

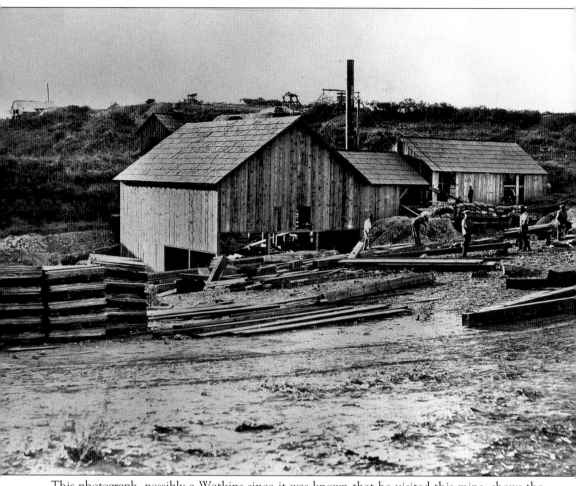

This photograph, possibly a Watkins since it was known that he visited this mine, shows the construction of the Princeton Mine's surface structures. Wood for steam, building, and shoring up the mine had to come from a distance because this mine was in an area covered with chemise, a low growing oily shrub, with little timber nearby.

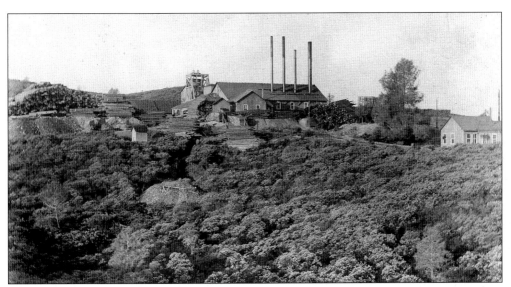

Here is a view of Princeton Mine from the east.

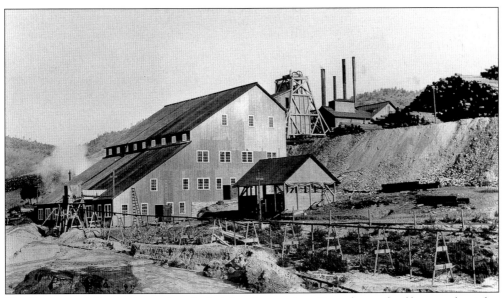

The Princeton Mine is pictured at the height of operation. Note the stack of logs on the right. The mine had its own sawmill, and logs from the Pilot Peak area were shipped by the wagon team provided by the Palmer family east of Bootjack to the mine. The logs were cut into timbers for the mine, and scraps were used in the boilers. The mill had 12 banks of 5 stamps, making it a 60-stamp mill. The running mill could sometimes be heard as far away as Mariposa, a five mile distant.

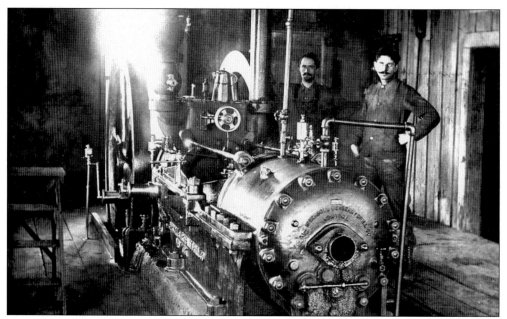

For its entire life, the great mill at the mine was run by steam. This steam engine caused the fire that burned down the engine house and ultimately the entire mill, c. 1913.

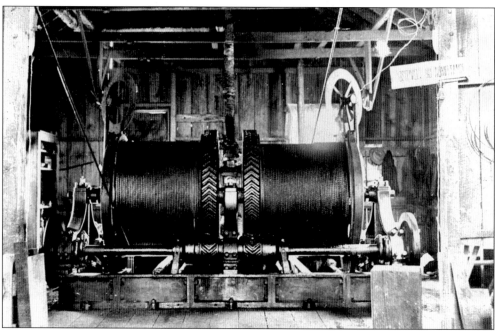

The hoist room contained large spools of cable that lowered and raised the ore buckets down the incline shaft. Electric motors or steam engines typically ran the wenches. Crews at shift change were supported the same way. The large round discs on either sides of the spools had footage numbers on them to indicate the depth of the cars.

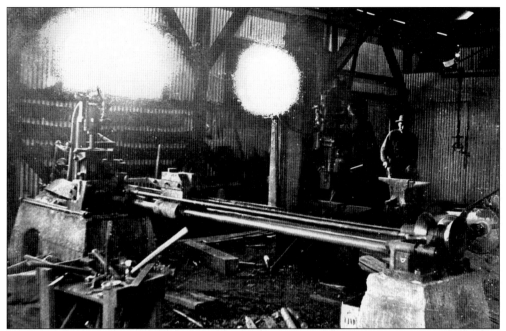

No mine was complete without a well-stocked machine and blacksmith shop. As much as possible, most equipment repairs and remanufacturing of parts took place here.

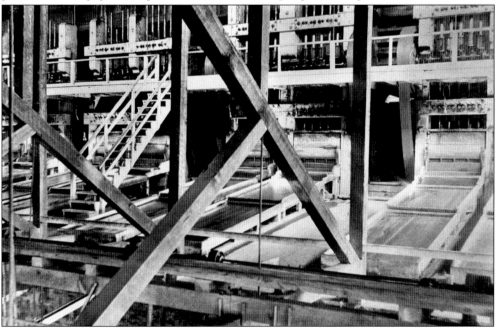

Pictured are a number of stamp mills and their separation tables. The crushed rock is pounded into a fine powder containing the gold. It is then washed across the tables, which are usually lined with copper plates, blanket material, or corduroy. A thin layer of mercury on the plates collects the gold. During retorting, the gold and mercury are heated to vaporize and collect the mercury into a condensing tube. This mercury is reused, while the gold is left in the bottom of the retort bowl.

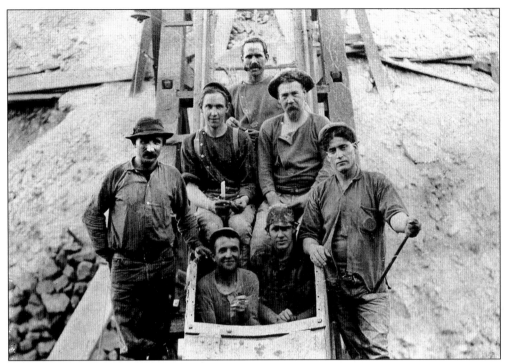

This Princeton underground mine crew is pictured before leaving for a day's work. Note the candle. A flickering candle kept underground warned miners that oxygen was running out. One of the greatest hazards of mining were the nitrites left in the air after blasting. Miners suffered from a number of respiratory problems caused by the silica from quartz drilling, as well as hazards from cave-ins, falls, and accidents. All of this took a heavy toll on miners who had no workmen's compensation insurance. Ultimately, the workers formed fraternal organizations to assist miners and their families.

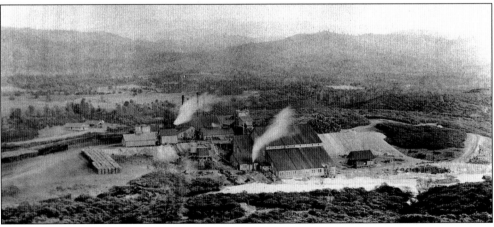

Princeton Mine is viewed from the west. The mine operated as much as the water available to it would allow. A number of times, failed attempts were made to bring Merced River water to the mine properties.

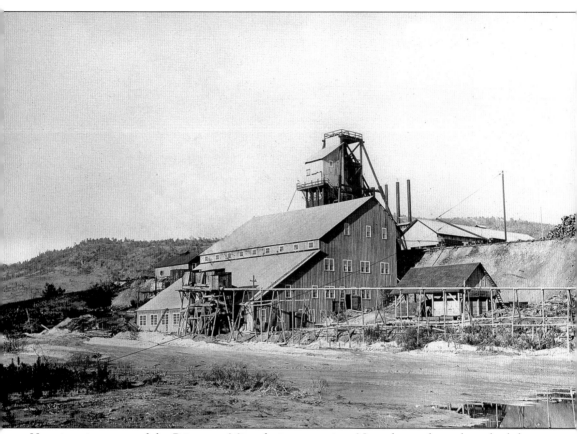

Here is a panorama of the Princeton Mine during operation. Note the cord wood on the left and the logs for timbers to the right. Large quantities of water and timber were consumed to keep the mine and mill operating.

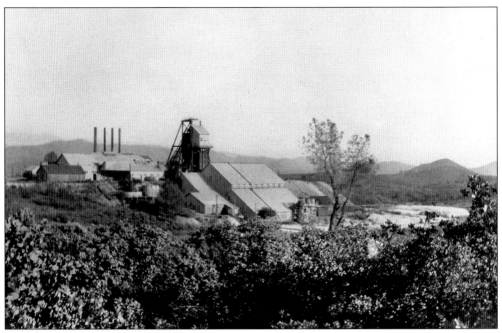

This almost romantic photograph of the mine was taken to entice new investors.

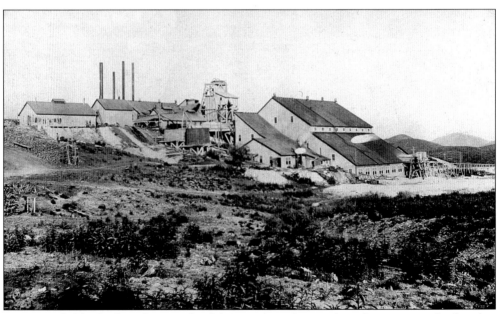

Here is probably the last photograph of the mine's surface works, taken prior to the fire that closed the operation. Note the not-so-romantic view of the surrounding area.

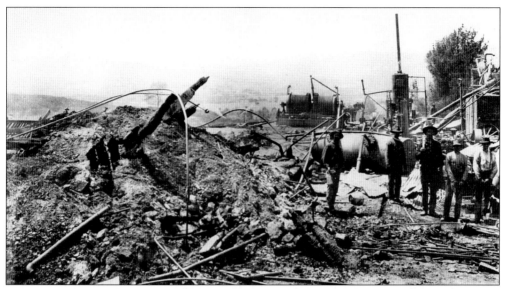

The c. 1913 fire in the engine house and hoist works was devastating. Many families were suddenly unemployed and had to move. Around this time, the lumber industry was beginning in the Yosemite area, and many of the men worked in the woods and mills there, staying as long as possible in Mt. Bullion.

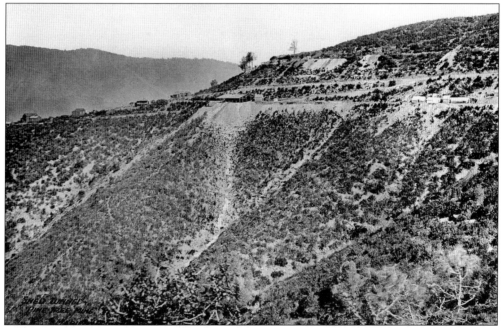

Prior to giving Fremont title to the property and assets north of Mt. Bullion, the Merced Mining Company developed many properties. This c. 1860 photograph shows the Pine Tree and Josephine Mines, which Fremont had taken possession of and was operating. The Merced Mining Company did not go quietly, and armed encounters occurred between Fremont's men and those of the Merced Company. The Battle of the Pine Tree Mine found men barricaded in the mine and Fremont erecting a "fort" on a hill above the mine opening. A peaceful solution was found, but the cost was heavy on both sides. (Carlton E. Watkins photo, 1860.)

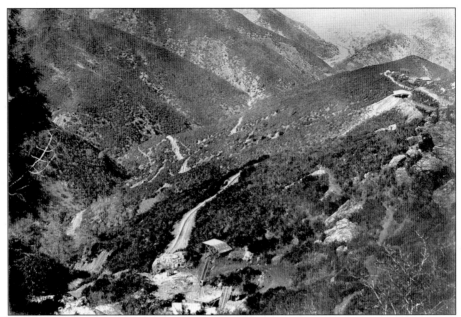

In this photo, the Josephine Mine is in the foreground and the Pine Tree is in the distance. Note the Merced River in the distance and the road that tortuously made its way to the mill on the river at Ridley's Ferry. (Carlton E. Watkins photo, 1860.)

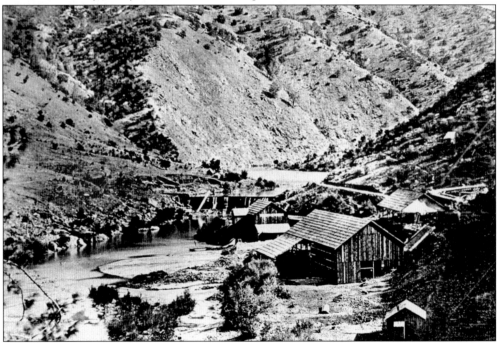

Fremont erected his mill at Ridley's Ferry on the Merced River. First he constructed a check dam on the river with a penstock, which directed water to the Peleton Wheel that ran the mill. The mill building is pictured in the middle, below the dam. News accounts reported that Fremont was planning to erect a 100-stamp mill in 1858. A road was cut from Bear Valley to transport the ore to the river mill.

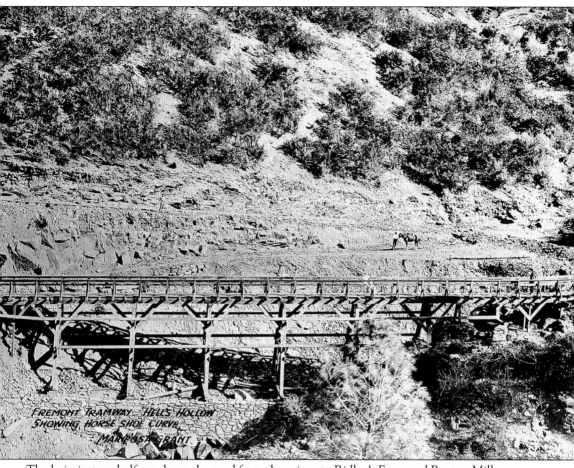

FREMONT TRAMWAY HELL'S HOLLOW
SHOWING HORSE SHOE CURVE
MARIPOSA GRANT

The hairpin turn halfway down the road from the mines to Ridley's Ferry and Benton Mills was too difficult for the ore wagons to negotiate. A tramway was constructed that reached across Hell's Hollow to lessen the difficult stretch. (Carlton E. Watkins photo, 1860.)

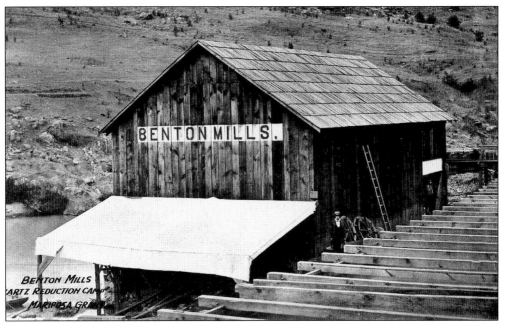

Fremont finally completed the mill in 1859, but it contained only 16 heavy stamps. Working 24 hours a day, the mill could reduce 25 to 30 tons of ore per day. Called Benton Mills, the facility honored Fremont's father-in-law, Thomas Hart Benton, senator of Missouri and the father of Jessie Fremont. The mill was destroyed by a flood in February 1862, when a landslide at McCabe's Flat, upriver, dammed the waterway. When the obstruction broke, a 60-foot wall of water coursed down the river, taking out the dam and the mill. (Carlton E. Watkins photo, 1860.)

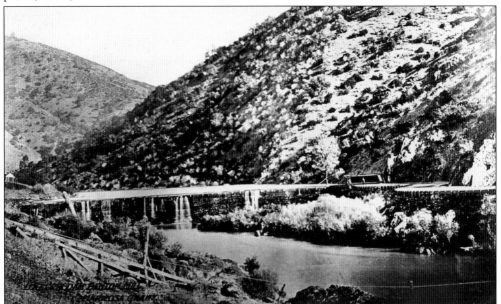

Fremont's men, using logs floated downriver and rocks to fill in the spaces, constructed this wooden crib dam at Ridley's Ferry. It diverted the flow of water into a penstock, which delivered water to the turbine, that powered the mill. (Carlton E. Watkins photo, 1860.)

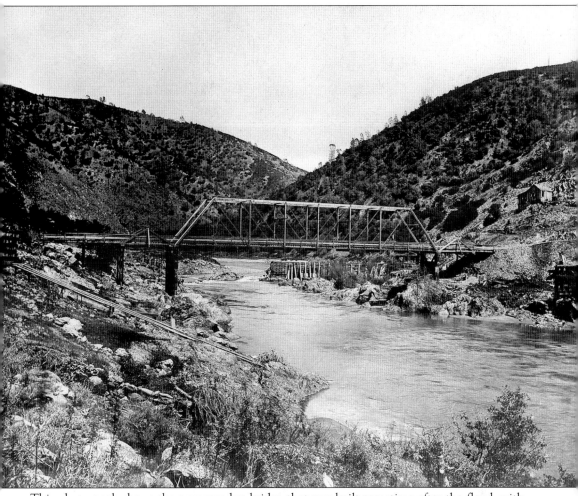

This photograph shows the new wooden bridge that was built sometime after the flood, with the badly damaged dam in the background. The remains of Ridley's Ferry is on the shore to the left and appears in the previous picture. Fremont was determined to rebuild the mill but locate it higher above the river, again using the river for power.

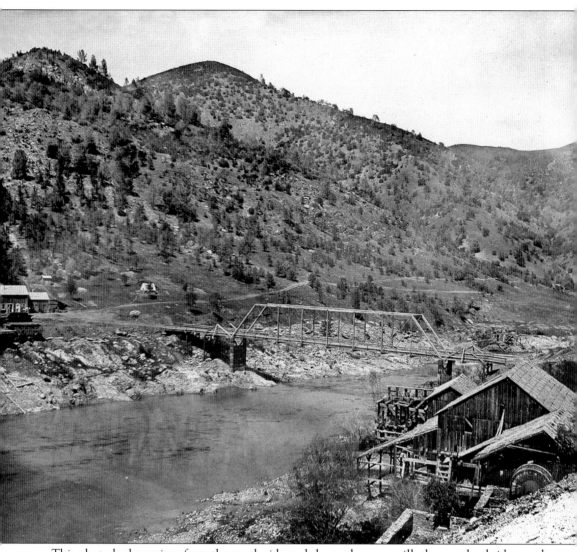

This photo looks upriver from the south side and shows the new mill, the wooden bridge, and some development across the river. The mill seems not to be in running order. While the date of the photograph is unknown, it seems to be before 1900. The name "Benton Mills" became the commonly accepted title by 1859, as Ridley died in 1852 while on a trip to Tennessee.

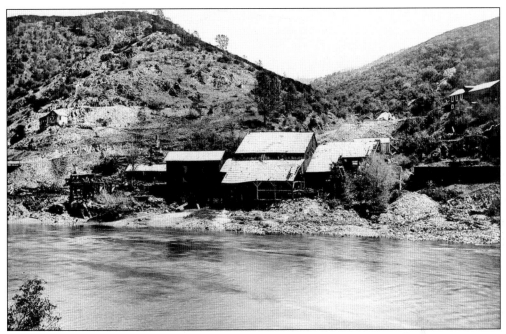

Pictured are the mill buildings on the south bank of the Merced River at Ridley's Ferry. Benton Mills would ultimately run with 80 stamps working. The mill used the Ryerson process in dry-milling and steam-activated amalgamation. After many years of operation (then abandonment), the structures were razed in 1895 by Abner Bagby to eliminate the hazards of decaying timbers.

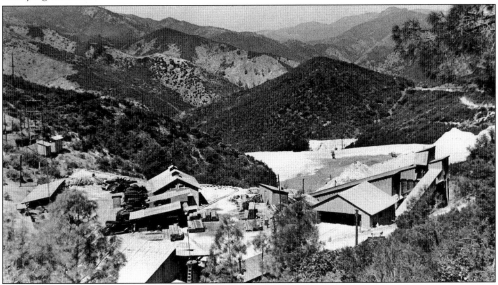

By the 1930s, the Pine Tree Mine was running again. The Depression in Mariposa County had a different effect. The gold mines reopened. Under the management of Frank McGuire, the Mariposa Commercial and Mining Company leased most of its mining properties. Miners from the San Joaquin Valley came to Mariposa County for placer mining within the grant on a seasonal basis, living in tents and tar-paper dwellings along the creeks. They sold their gold in Mariposa at Trabucco's store, often trading for goods. (Courtesy of Joan Radanovich.)

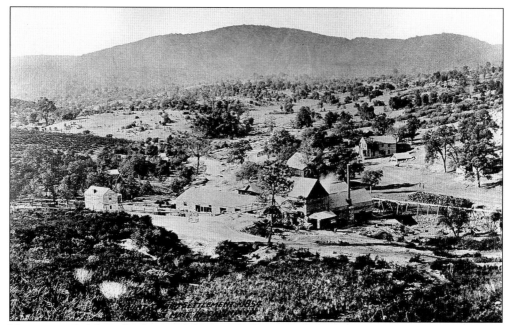

Norwegian Gulch is the home of the Mt. Ophir Mine, which was developed by the Merced Mining Company. It became the focus of a legal case, *Biddle Boggs v. the Merced Mining Company*, which decided the fate of improvements made by the mining company after the Supreme Court granted clear title, including the mineral rights, to Fremont. (Carlton E. Watkins photo, 1860.)

At the Mt. Ophir Mine office, slugs of gold were marked to describe their fineness, then sent to the Moffitt Mint in San Francisco to be made into gold coin. While miners were panning in the creeks, most transactions were made with gold dust or nuggets. Merchants measured the dust or nuggets on a scale that had to be accurate for the miners to trust them. Disagreements could turn violent. Gold from industrial mining entered the market as a commodity to pay for goods and services, as well as to pay investors. (Carlton E. Watkins photo, 1860.)

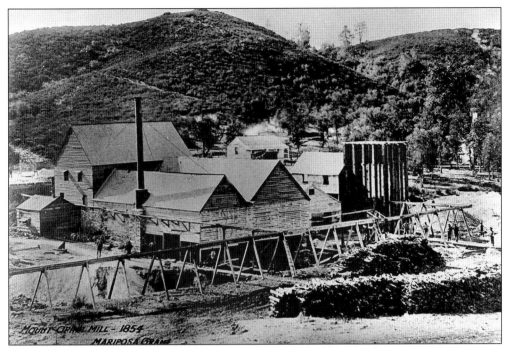

This Watkins photograph takes a closer look at the mill building for the Mt. Ophir Mine, at a time when it belonged to Fremont. It was a tunnel mine with the opening on the side of the mountain. Ore was brought to the mill in wagons and processed there. This mine eventually proved to be far less valuable than Fremont had expected, and it soon closed. (Carlton E. Watkins photo, 1860.)

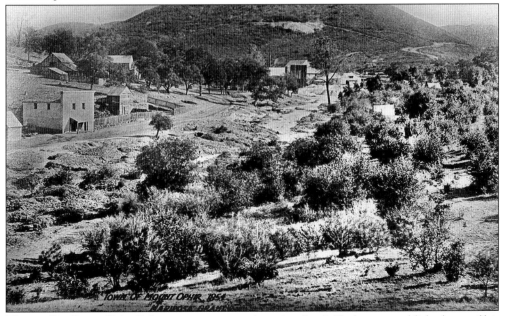

The small village of Mt. Ophir sprang up near the mine. Louis Trabucco established one of his stores here in the two-story building pictured on the left. The mine scar shows in the background. (Carlton E. Watkins photo, 1860.)

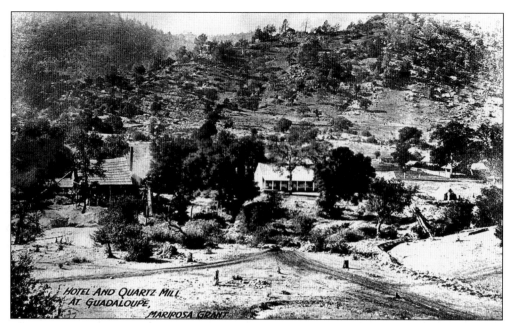

This 1860 photo shows Guadeloupe Hotel and Quartz Mill. Guadeloupe was a placer mining area on Agua Fria Creek, on Fremont's land. One of the first water-powered mills was erected here by Capt. John Diltz, pioneer developer of the Diltz Mine in Whitlock. The lack of dependable water inhibited development of this area, though placer mining continued on the creek in the 1930s. Eventually, the county rented the hotel building and established a "pest house," probably for patients with consumption. (Carlton E. Watkins photo, 1860.)

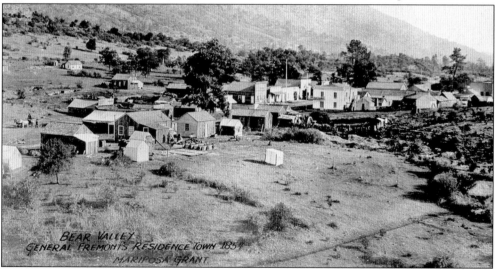

Bear Valley, about 10 miles north of Mariposa, was the headquarters for the Fremont Grant Company and home for John and Jessie Fremont. Although they lived there less than two years, their presence made a significant impact. Jessie collected stories about her time spent in Bear Valley and Mariposa, and published them as *Far West Sketches*. Mariposa author Shirley Sargent later published a selection of Bear Valley stories as *Mother Lode Narratives*. Bear Valley was originally called Johnsondale, Frederick Law Ohlmstead lived over the company store for two of the three years he was in California. (Carlton E. Watkins, 1860.)

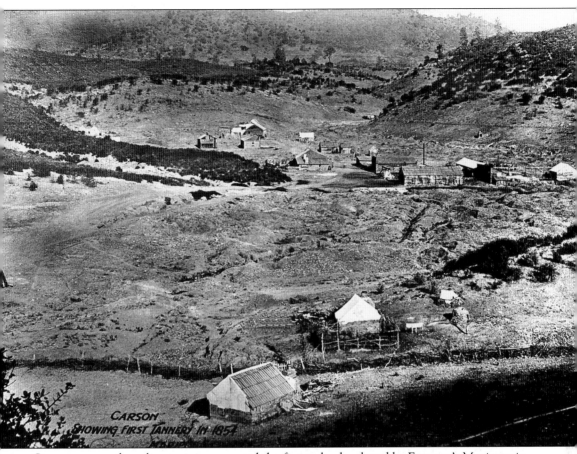

CARSON
SHOWING FIRST TANNERY IN 1854

Carson was another placer mining area and the first to be developed by Fremont's Mexicans in 1849. Named after Fremont scout Kit Carson, it became the site of the first tannery in the Southern Sierra. Note the black cone-shaped tent on the far left. That was Watkins' darkroom. (Carlton E. Watkins photo, 1860.)

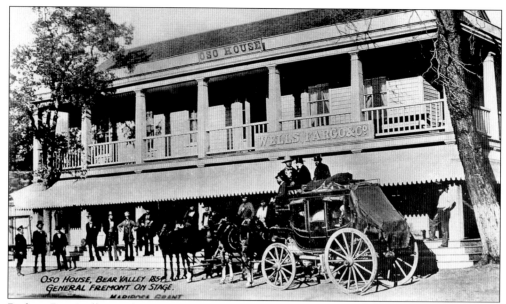

Built in Bear Valley in the mid-1850s, the Oso House (Spanish for "bear") served both as hotel and office for Fremont. The man with the beard on top of the coach may be Fremont, or may just be an impersonator. The Oso House served mostly as a dormitory for miners who paid upwards of 50¢ a day for room and board. In 1930, a grass fire ignited the structure. It was further complicated by the storage of dynamite in one of the rooms. (Carlton E. Watkins photo, 1860.)

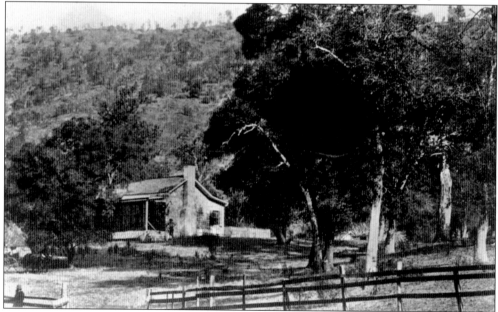

The Fremont Cottage in Bear Valley has been described as the "Western White House," alluding to Fremont's run for the presidency. A more accurate description is that it is a collection of miners' shacks that were pushed together and decorated by Jessie Fremont to provide a home for the "Pathfinder." Jessie's short stories contain many references to times and activities during her year and a half spent in Bear Valley and Mariposa County. (Carlton E. Watkins photo, 1860.)

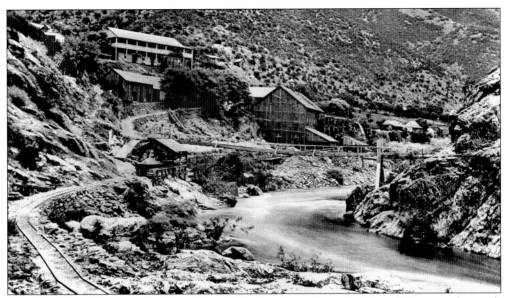

The Hite Cove Mine was developed about 10 miles above the main Merced River, on the south fork. Hite came to Mariposa County around 1850 and mined on Ned's Gulch along the main river. He heard of the rich placer mining occurring up the south fork, and ventured to find the source. His discovery made him perhaps the only millionaire miner created by the wealth of Mariposa County. His mine had a family boardinghouse that also served as a school, an electric power plant driven by the waters of the south fork, and a large mill.

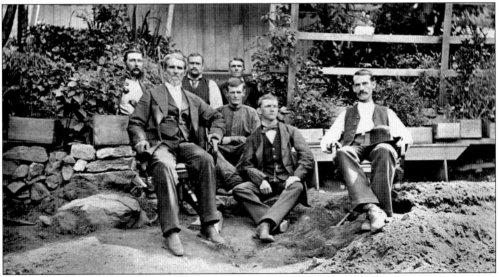

Hite, left front, and a group of his miners are pictured at Hite Cove. When John left the cove, he abandoned his Native American, common-law wife, Lucy. Their marriage was legitimized by an Indian ceremony. Lucy's son by another man later read an article in a San Francisco newspaper, which reported that John had married a nurse he met while hospitalized for pneumonia. Lucy sued John for divorce, a legal action not available for common-law marriages and not available to Native Americans. The action moved from Mariposa to a court in San Francisco, where Lucy was given a divorce, recognized as having stood before the court (a first for a Native American), and awarded a cash settlement—most of which disappeared.

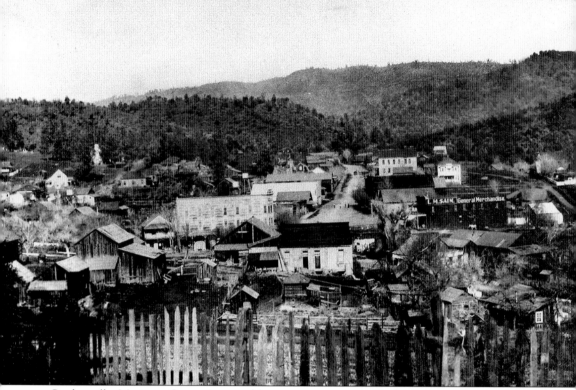

Coulterville, Mariposa County's second-largest town, was outside the Fremont grant and north of the Merced River. The mines in the area proved to be rich and free of Fremont's legal entanglements. The town was named after George Coulter, who started a store on Maxwell Creek that was housed in a tent with a little flag on its peak. The mining camp originally grew around a Mexican square and was called Banderita, after the tent's little flag. In the photo just left of center is the three-story Jeffrey Hotel. Although the structure experienced at least two fires over its lifetime, it has been restored and maintained over the years and is still in use today. The last major fire occurred in 1899 and destroyed Coulter's Hotel. The walls of the old hotel surround today's Northern Mariposa County History Center.

The Coulterville Road, built by Dr. John McLean, made its way to Cascades (and thus to Yosemite valley) almost a year before the Mariposa Road from Wawona. Along the route, stages stopped at Dudley Station and Bower Cave, as well as Hazel Green. The trip down the steep grade leading to the Merced River was spectacular, with wonderful views of the river canyon below Yosemite Valley. The road is defunct today because of a rockfall during the 1980s, but sections can be traversed carefully on foot.

Five

RIDLEY'S FERRY BECOMES BAGBY

With the decline of the Grant Company, Benton Mills at Ridley's Ferry closed. The mines reopened in the late 1880s with the formation of the Mariposa Commercial and Mining Company. By 1900, it was evident that a different and more dependable source of power was necessary to make the company profitable. Building new facilities at Mariposa and Mt. Bullion was followed by the construction of a hydroelectric power plant on the Merced River. This construction, along with the beginning of the Yosemite Valley Railroad that moved up the Merced River from Merced, reached Benton Mills *c.* 1905. The railroad and renewed mining brought many laborers, miners, and storekeepers. Abner Bagby arrived at Benton Mills in 1897 and started a store and hotel. In 1898, he married a hotel employee, widow Ruth Rowland Greider. They had twins, Everett and Winifred, who turned out to be the delight of the community.

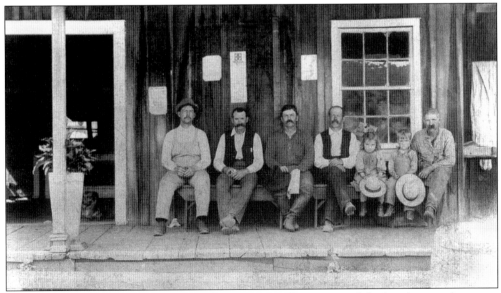

The Bagby twins were a regular part of the scene at Bagby's store and the hotel across the street. With few other children in the village, they grew up rapidly. Winnie eventually married Herman Freyschlag, a miner who spent many years at the Clearing House Mine. They had one child named Winifred. Everett, a well-known athlete, went on to become the Mariposa County assessor and probation officer, and married Rhesa Hall. They had a child named Ellen. The Bagby family contributed greatly to the history of Mariposa County.

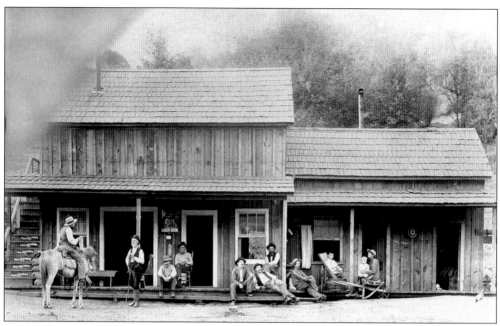

The Bagby Store was the center of daily life in the little river and railroad town.

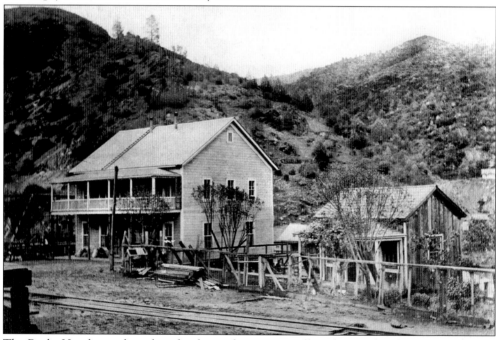

The Bagby Hotel served as a boardinghouse for miners, mill workers, railroad men, power plant operators, rail passengers, and loafers. Over the years, various attractions included a thriving garden and a busy kitchen, as Mrs. Bagby served three hearty meals a day for a mostly male clientele. Once called Ridley's Ferry and Benton Mills, the town was renamed Bagby without Abner Bagby knowing. True or not, Everett Bagby reported that when the first bag of mail arrived, it was all addressed to Bagby, California. Abner, not knowing any different, thought it was all for him.

Pictured is Abner Bagby, proprietor of the Bagby Store.

Here is Mary Rowland Bagby, proprietor of the Bagby Hotel and mother of Everett and Winifred Bagby.

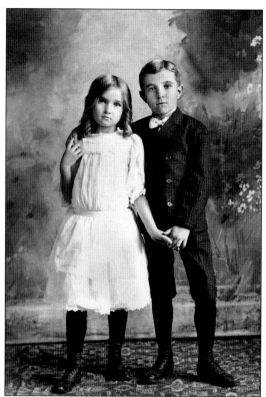

Young Everett and Winnie, the twins, hold hands.

Elizabeth Winnifred "Winnie" Bagby posed for this photo without her brother.

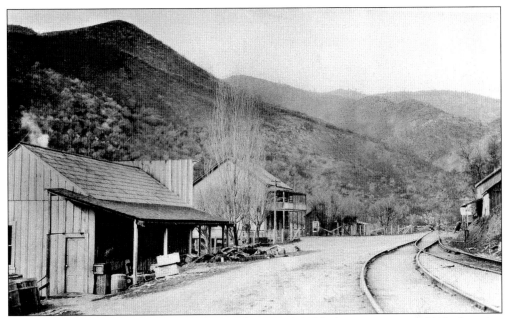

The Yosemite Valley Railroad arrived in Bagby in mid-1906. A station was established to give travelers access to Mariposa via the mine wagon road to the south. After it was completed, visitors to Yosemite could go to Bagby by coach or automobile, and ride the train to El Portal. Pictured on the left are the Bagby Hotel and Store.

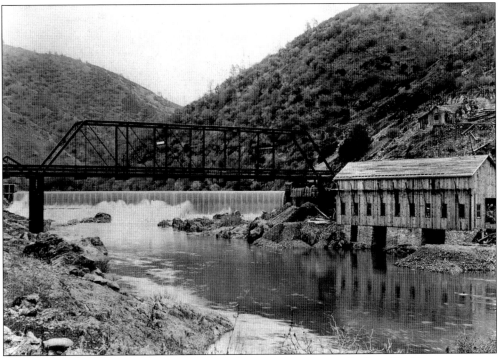

The Mariposa Commercial and Mining Company constructed this 400-kilowatt, water-generated powerhouse and dam in 1903. It became the first source of electric power for the mines, businesses, and residences within the Fremont grant land.

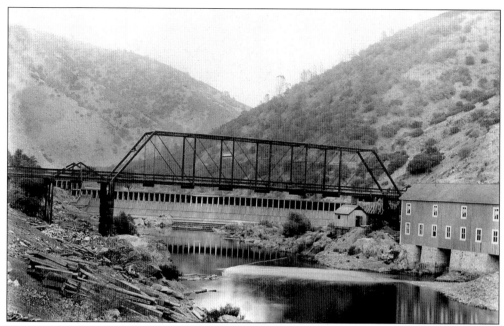

This wooden dam impounded water for the operation of Benton Mill. In the summer and fall, water did not run over the structure.

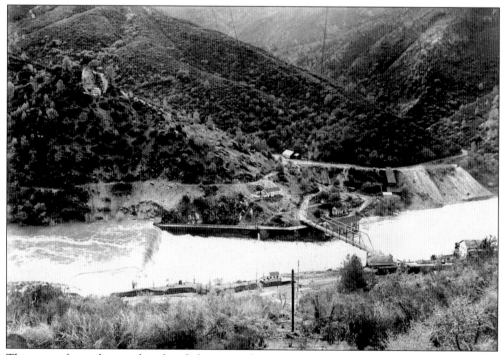

This view from the north side of the river shows the dam, bridge, and powerhouse. Also pictured are the first train station, the hotel, and the mine road from Bear Valley, as well as the mines in between.

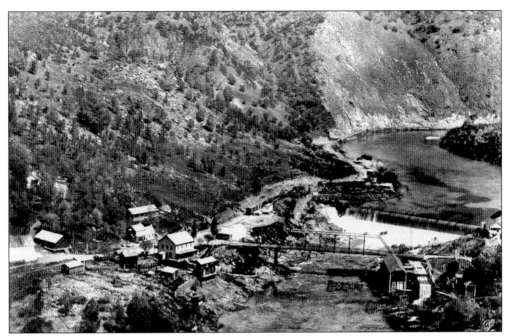

This *c.* 1910 photo shows the railroad as well as the powerhouse and various buildings. By this time, Bagby was an important stopping point.

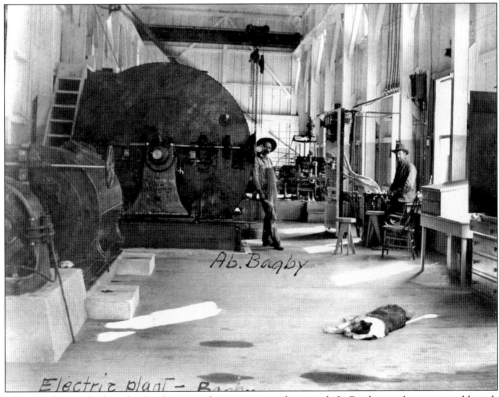

Ab. Bagby

Electric plant - Bagby

"Ab" Bagby worked in the Bagby powerhouse as a mechanic while Ruth ran the store and hotel.

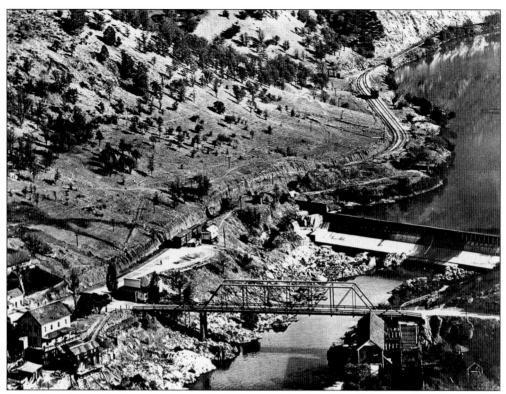

Low water during the late season revealed dam construction. The dry penstock indicates that the mills were closed. A rail car is visible on the siding.

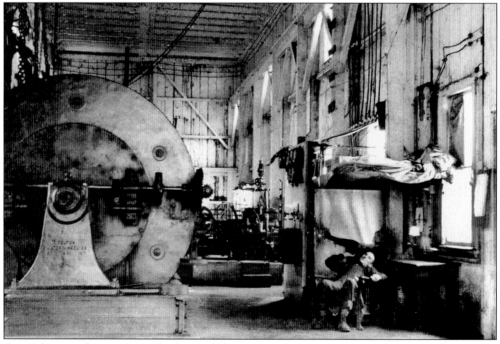

Gus Schwing takes a nap inside the powerhouse.

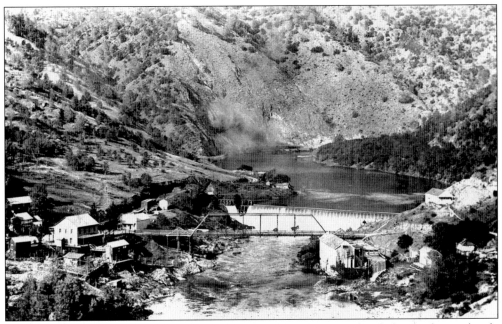

The Yosemite Valley Railroad train leaves for Yosemite. By 1927, a brush fire on the south side of the river burned the powerhouse, flume, bridge, and other structures. For two years, Mariposa was without power, until San Joaquin Light and Power purchased the distribution lines and reestablished service.

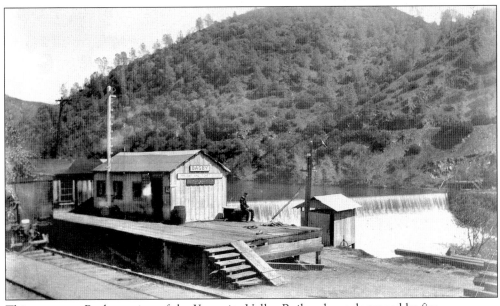

This one-story Bagby station of the Yosemite Valley Railroad was destroyed by fire.

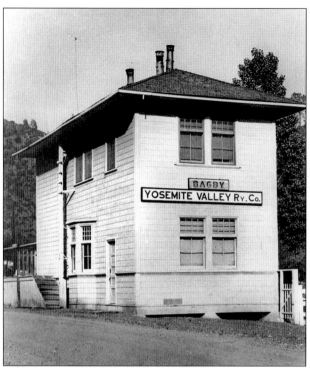

This building, the second Bagby station, is now located in El Portal and serves as the headquarters of the Yosemite Association.

This was the last log train to arrive at El Portal, in 1942. Heavy flood damage on the railroad bed in 1937 shortened the rail line. The last of the logs came from the incline below El Portal and were delivered to the sawmill at Merced Falls.

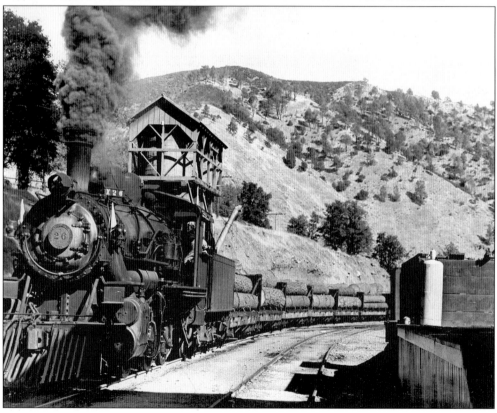

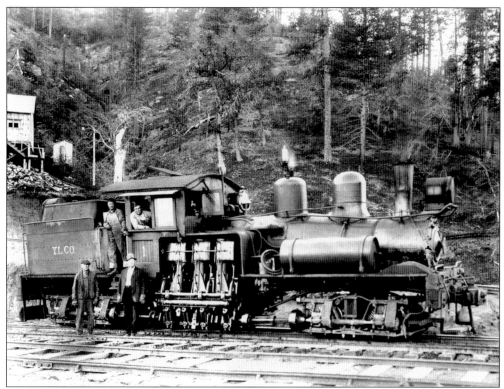

Railroad logging in the Sierra comes to an end with World War II. The Shay engine, with its direct drive, is no longer heard in the woods and the tracks are gone. Although today, if one wants to ride a Logger, the Yosemite Mountain Sugar Pine Railroad is still giving tourists the thrill of riding through the woods in Fish Camp, California.

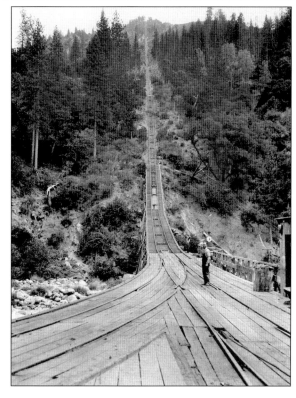

Sugar Pine logs are cut in the forest above 4000 feet and lowered into the canyon of the Merced River on the bunk cars. Cables control the decent of the cars as well as a second string of cars going up the incline. Once at the bottom, the cars are made up into trains for the trip to the sawmill at Merced Falls via Bagby.

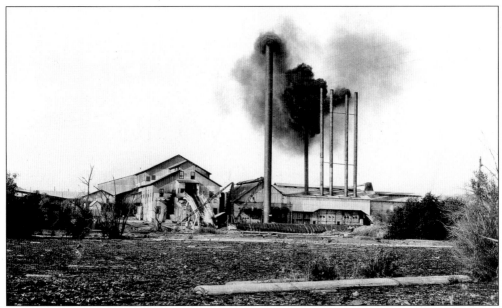

The end of the line for the Sugar Pine logs delivered by the Yosemite Valley Railroad was the mill and powerhouse at Merced Falls. The company town of the Yosemite Sugar Pine Lumber Company supported many families of Mariposa and Merced Counties, and offered housing, entertainment, and medical facilities. The only reminders of this once-thriving mill are the cement foundations and mill pond along the lower Merced River.

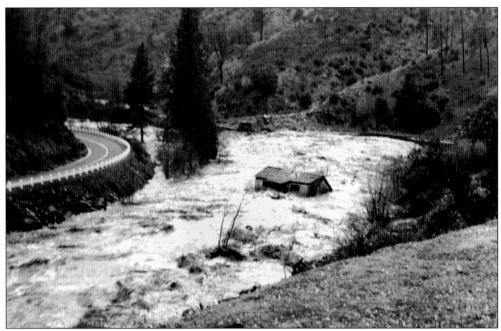

The rampaging Merced River, pictured here in 1937, carries a house downriver at the Clearing House Mine. Flooding was the downfall of the Yosemite Valley Railroad as well as ending logging and mining along the river. Major floods also occurred in 1950, 1955, and the biggest in 1997.

Six

MEN AT WORK
AND PLAY

Mariposa County has always been dependent on the development and use of natural resources. Mining, logging, farming, and grazing have been the principal activities. The hard work brought working men to the county who also liked to play hard on the weekends. Saturday night was big time, with dances going on in many areas of the county. Whole families attended, and each community or area had their favorite dance hall at such places as Mariposa, Hornitos, Darrah, Bootjack, Midpines, El Portal, Coulterville, and Greeley Hill. Sunday was a day of rest and recovery.

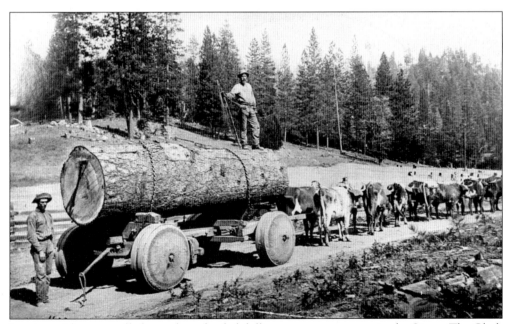

Logging with oxen-pulled, wooden-wheeled dollies was very common in the Sierra. The Clark family of Midpines and Jerseydale operated a series of sawmills, from Clark Ranch (now Highway 140 at Triangle Road) to Clark Valley in Jerseydale.

The David Clark family was in the sawmill business from 1852 until just after World War I. In this Robinson photo, young Dick Wass stands atop the logs on the dolly, with the saw mill in the background. Lumber for the courthouse probably came from the Midpines Mill.

A livery stable was common business in the early days before automobiles and trucks. This stable, originally called Turners Stable, was on Charles Street between Sixth and Seventh Streets.

Miners from Cornwall, England, were recruited by the owners of Mother Lode Mine because of their experience in hard rock mining. Their skill at removing water from mines and their understanding of the process made them valuable workers. Jim Tresidder and his brother Martin came to Mariposa and established a family that followed mining and work underground for at least three generations. (Courtesy of June Meagher.)

"Double jacking" was a mining technique that was ultimately replaced by hydraulic drills and dynamite. The method involved one miner holding the steel bit while the other drove it into the rock with a hammer. The resultant hole was then packed with black powder. An explosion fractured the rock, which was carried to the surface for milling.

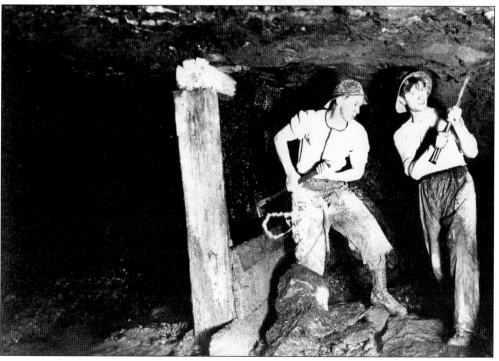

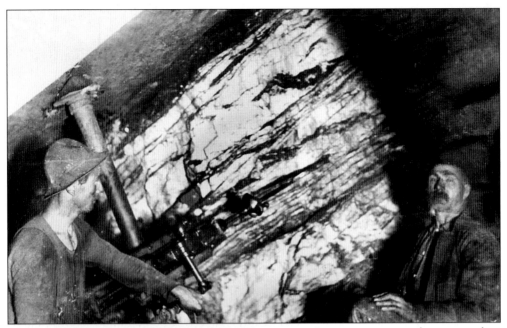

Large compressors above ground provided air to run the drills and pump in fresh air for the miners. These men are working on a vein in the Mariposa Mine.

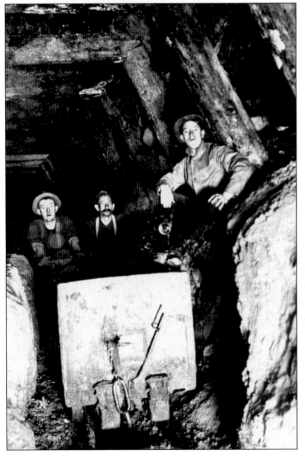

As mines got larger, ore cars were moved on rails through tunnels, either by man, mule, or small electric engines. Heavy timbering of the mines was necessary to prevent the cave-ins that plagued the Mother Lode.

Early in the 20th century, four-wheeled horsepower replaced the four-legged variety. Charlie McElligott and his brothers operated a machine shop in Mariposa. Their father, Patrick, had operated a livery stable and freight business. The brothers acquired a franchise from the Ford Motor Company c. 1918 and converted their shop into an automobile sales and service establishment. This entrance was on Fifth Street, with gas pumps out front and a showroom indoors.

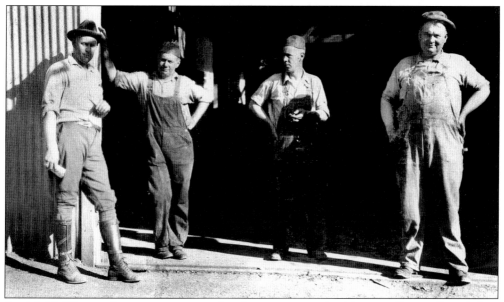

Patrick McElligott's four sons are pictured at the entrance to the Mariposa Garage. From left to right, they are Merwyn (who was not in the garage business with his brothers), Maynard (Buster), Charlie, and J.P. (Jim). The brothers continued the business until the late 1930s, when Charlie's son Doug took over the operation.

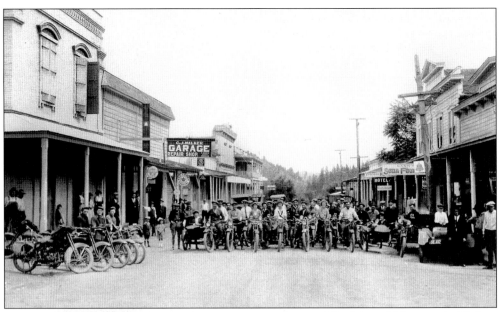

The Merced Motorcycle Club came to Mariposa in 1918 for a tour and races on Charles Street, which at that time was still paved with dirt. The townspeople turned out to see the machines and well-dressed ladies riding in the sidecars.

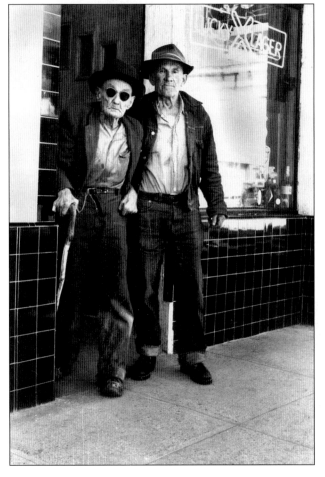

Pictured here, from left to right, are two old timers, Frank Rupe and Emory Story. Emory's father had mined north of Mariposa and spent much of his life as a helper for the Trabucco family at their store.

Bob Fat was a cook at the Whitlock Mine. He had a cabin at Whitlock Gap, where he grew vegetables and hunted. He taught many young men to hunt and was well respected. (Courtesy of June Meagher.)

James Monroe was a stage driver for the Washburns of Wawona. He was considered to be the best. His family homesteaded at Pea Ridge, south of Mariposa. When the wagon he was driving wrecked, he disregarded his own safety and saw to the welfare of his riders. Internal injuries from the accident caused his death. His funeral service was held at Mariposa Methodist Church, and he is buried at the Mariposa Cemetery. (Courtesy Yosemite Museum.)

93

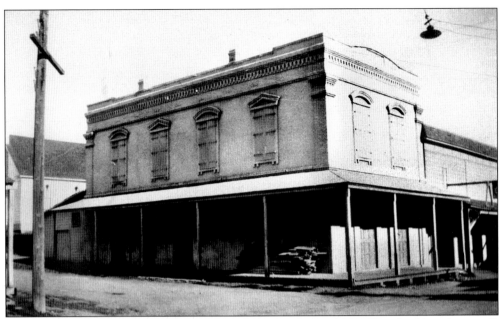

During and after World War I, Mariposa was very quiet. The Odd Fellows building (pictured) has been around since 1868 and is still in use. When this photograph was taken, the ground floor was still being used as a warehouse. Electricity had come to Mariposa from Bagby, as evidenced by the streetlight.

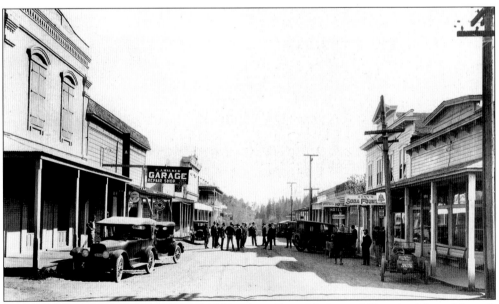

Charles Street was still just dirt until 1924, when State Highway 140 arrived from Merced. Note the wooden sidewalks and the gas pumps in front of Charlie Walker's garage.

In 1926, Jay P. and Wanda Miller opened the
Mariposa Drug Company in the IOOF building.
State All-Year Highway 140 to Yosemite joined El
Portal to Coulterville Road at Cascades,
and thus to Yosemite Valley. Mariposa's main
street was still dirt, but not for long. Charlie
Walker's garage sold Red Crown gasoline.

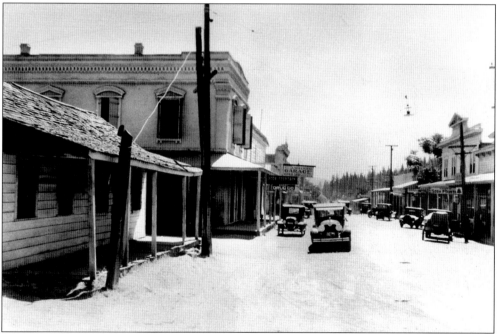

The new highway brings Mariposa to life again. The building on the left has been used as a
mortuary during highway construction and the whole town knew when there had been an
accident. The mortuary was later replaced by a Richfield Service Station, then in 1959 by the
Mariposa Drug Company.

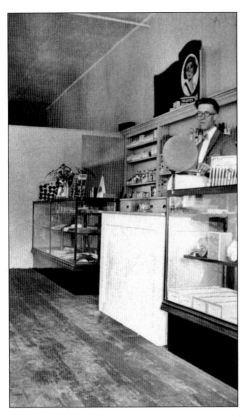

Jay P. Miller is pictured behind the counter of his Mariposa Drug Company in the IOOF Building. Prior to that time, medicines were dispensed by physicians in their offices, which doubled as drug stores. Before Miller's store, Dr. Burnett's office on the east side of Charles Street was, in 1895, also the terminal for the Sunset Telephone Company of San Francisco. Dr. Burnett later moved his office, the Mariposa Drug Store, and telephone company into the new Stolder Building on the west side of Charles Street. Besides the drug store, two other phones were available in town—one at the courthouse and one at the *Gazette*.

Wanda Miller and E.J. "Bub" Johnstone are pictured in front of Mariposa Drug Company. The inscription on the back reads, "Pregnant, but not by the officer." Wanda and Jay lived in the back of the drugstore for many years, until they could afford to build a house. "Bub" started as a county patrol officer. When the State took over patrolling the highways, he switched over to the California Highway Patrol. He retired as a captain in the 1960s.

Pictured are Wanda and a young employee at the front door of the early Mariposa Drug Company. The Odd Fellows building that contained the drugstore still had the steel shutters and doors that were installed in 1868 to forestall another fire from destroying the building. The roof was made of sod, and the walls of fireproof brick. The author's father acquired the drugstore in March 1943. Within a couple of years, it was decided that the sod roof should be removed. Every crack in the building was stuffed, and still the dirt came into the store. Men with scoop shovels dumped it into the street, two stories below.

By the 1930s, Jay and Wanda had remodeled the front of the drugstore with tile and plate-glass windows. Just inside the front door was a ceiling fan to keep flies out. Other ceiling fans were the only cooling that the store had besides high ceilings and thick brick walls. This is how the store looked when the author's father purchased it. Note the penny scale to the left.

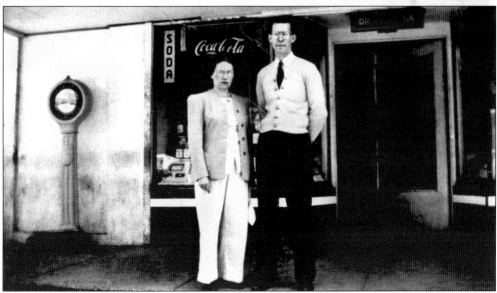

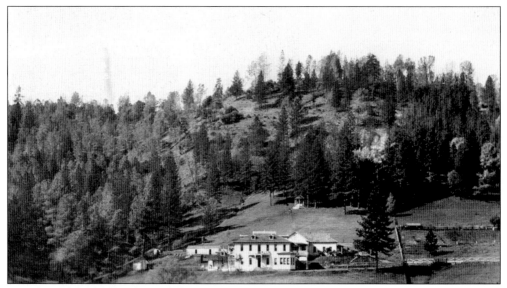

In 1898, Dr. Conrad Richter purchased Pine Knoll. On the west side of Mariposa Creek, where the present-day Recreation Department and Park is located, Dr. Richter built the sanitarium that would carry his name. Completed in 1901, the facility was sold in 1903 to the county, which added a second building behind the main structure. A small building was added to the south of the county hospital, as it was now called, to provide housing for patients with communicable diseases. Known as the "Pest House," this was not the first of its kind in the county. By 1919, the State of California condemned the building, and the patients were transferred to Merced and Madera.

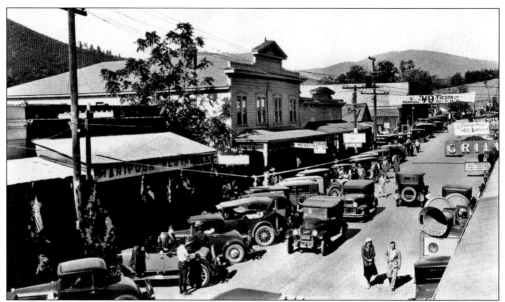

Mariposa merchants attempted to bring business to Mariposa during the Depression by sponsoring 49er Fiesta Days. Parades, dances, street gambling, and other activities drew many people to Mariposa.

Mariposa's 49er Days began the tradition of selecting a queen and her court for special events. On the far left is Pearl Carter (Williams), and at far right is Kay Dexter (Olson). The queen is Dorothy Apperson, and the man is Ott Abbott. The little girl in the middle is unidentified. (Courtesy of Pearl Carter Williams.)

The last stretch of the All-Year Highway to Yosemite, from El Portal, was not technically a state project because it was within the park. Financial assistance to finish the road came from the Automobile Club of California. A crew of local men maintained the new highway, including, from left to right, (front row) Merritt Thomas, Garfield Carter, unidentified, George Rhoan, and Kenny Meyers; (back row) unidentified, John Houlihan, Hugh Parker, and Errol Hodgsen.

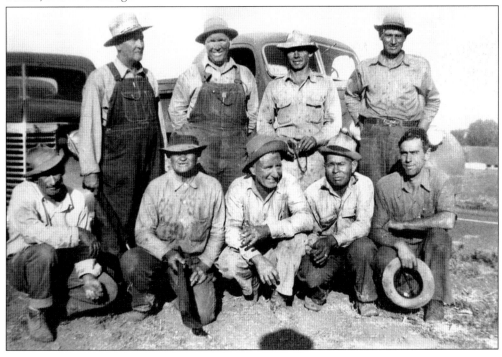

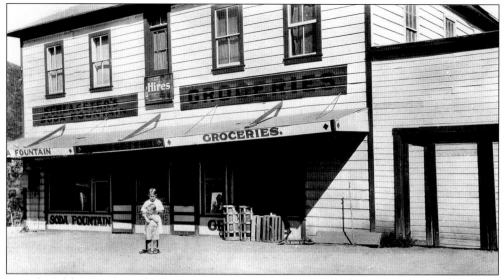

Temple Schlageter drove buses in Yosemite. At about the age of 18, a young woman from Chicago named Myrtle came to Yosemite to work at the Teneya Lake High Sierra Camp. Temple and Myrtle met on the job, fell in love, and were soon married. Temp's father helped the couple buy the Camin Hotel at Seventh and Charles Streets. They converted it into a market and soda fountain, though upstairs remained the open bay hotel. In this photo, the boys in the street in front of the store are are their sons, Raynor and Temple Jr. Raynor died of diphtheria while with his mother on a trip to Chicago. Young Temple survived to become an executive with the Zellarback Paper Company. He was a friend to practically everyone in Mariposa. (Courtesy of the Schlageter family.)

The new Highway 140 turned right on Seventh Street, in front of Temple and Myrtle Schlageter's IGA store. Yet to be paved, the road passed up Seventh, turned left onto Bullion, continued to Eighth Street, turned right, and on to Jones Street. Then it continued up Eighth Street, passed the high school, and ended at Midpines. Jones Street later became State Highway 49, which has its terminus at Eighth Street. (Courtesy of the Schlageter family.)

With the opening of Highway 140, buses could travel from Yosemite to the train in Merced, thus bypassing the Yosemite Valley Railroad. The Schlageter store and soda fountain in Mariposa became the rest stop for the trip. In this photo, two of the most common types of buses are parked in front of the store. In front is the White Company bus, which is older, and behind is the new Cadillac bus, which was longer and lower for a gentler ride. Note that Highway 140 is paved in this photo. (Courtesy of the Schlageter family.)

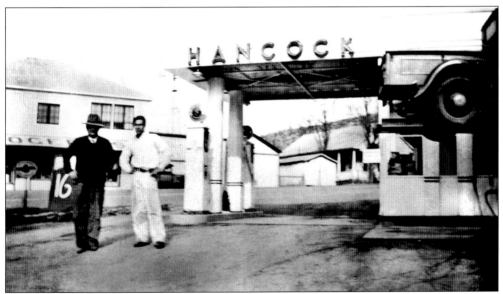

Across Seventh Street from Schlageter's was the Hancock Service Station. Note the outside lube rack. The station faced the turn in the highway as it went up Seventh Street. (Courtesy of the Schlageter family.)

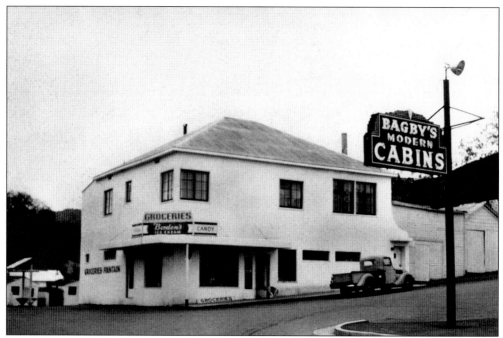

By 1940, the State of California decided to reroute Highway 140 north from the intersection of Seventh and Charles Streets. Instead of following Charles Street, the road would veer off to the west, thus subdividing a number of yet-to-be-developed town blocks. This later proved to be a problem for the community. Schlageter's store was stuccoed and lowered to accommodate the grade of the new highway, and the upstairs was converted into a three-bedroom house, with access on the far right end of the building. The Bagby's sign in the photo refers to the motel that was owned by Everett and Rhesa Bagby, the famous Bagby twins. (Courtesy of the Schlageter family.)

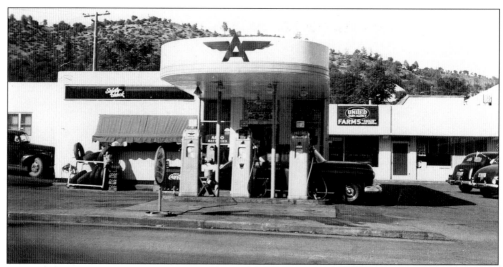

The Hancock station was removed, and a modern Flying A Associated station was built, complete with an indoor lube room. The rest of the buildings around the station were added in 1946. (Courtesy of the Schlageter family.)

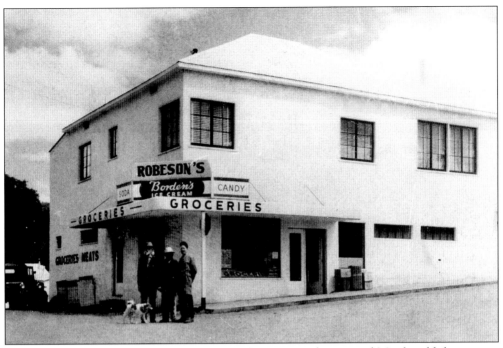

Toward the end of World War II, Temple Schlageter passed away, and Myrtle sold the store to Ruth and Joe Robeson. When Joe retired, Ruth became a very successful real estate broker and, for many years, the secretary for the Mariposa County Chamber of Commerce. (Courtesy of the Schlageter family.)

MYRTLE W. SCHLAGETER

Announces the Opening of

THE FASHION BAR

Wednesday, October 13, 1948

Complete Line of Ladies' Ready-to-Wear

Costume Jewelry Hosiery Lingerie

Special Orders Given Immediate Attention

Myrtle Schlageter opened a ladies' ready-to-wear shop in a section of the grocery store. This card announces the October 13, 1948 opening. By 1951, she had married Thomas McSwain, a retired Merced irrigation engineer who took a great interest in Mariposa. Myrtle lived well into her nineties. (Courtesy of the Schlageter family.)

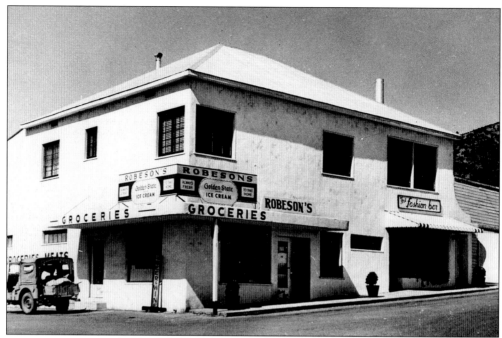

In this photo, Myrtle's Fashion Bar can be seen to the right of the grocery, which is now called Yosemite Market. The market passed through the DeCaro family, Enos and Ann Orcutt, and Stan Pierce before it became Sierra Stationery. The building, once a hotel, is still in use today. (Courtesy of the Schlageter family.)

By the end of World War II, rural electrification came to Mariposa in the form of Pacific Gas and Electric Company. This group of men, all local, made up the contraction crew responsible for installing many miles of electric line. From left to right, they are Billy Lewis, Dick Wass, Ray Chapman, Ray Dethridge, Bill Johnson, and Morris "Mose" Oliver. (Courtesy of Irene Varain.)

Pictured is the PG&E service crew that also did construction. From left to right are John Varain, Ray Chapman, Al Segale, Eugene Fournier, and Walter "Sliv" Vanderbunt. (Courtesy of Irene Varain.)

Bill Purcell (left) was a clerk for the Mariposa PG&E office, and Elwyn "Dutch" Reynolds was the manager. Purcell had served during World War II in Navy Intelligence and worked later as a real estate agent. Reynolds was in the Army Air Corps and was very active in Mariposa affairs. He was in the Mariposa Lions Club, the chamber of commerce, and a founding member of the Highway 140 Association. He helped install street signs throughout the town. (Courtesy of Irene Varain.)

PG&E meter readers Stan Meline (left) and Slim Hardwick pose in front of a service truck. Hardwick had been with PG&E since the purchase of the Mariposa Commercial and Mining Company system by San Joaquin Light and Power, and he was involved in building the transmission lines into Yosemite Valley. (Courtesy of Irene Varain.)

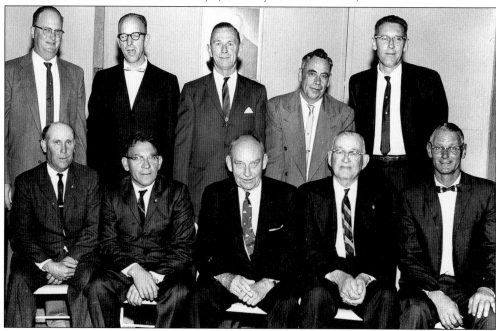

Past and present PG&E employees in this 1970s photo include, from left to right, (front row) Billy Lewis, equipment operator; John Varain, lineman; "Dutch" Reynolds, manager; Al Segale, construction; and "Sliv" Vanderbrundt, lineman; (back row) Clifford "Smitty" Smith, line foreman; Norbert "Norm" Varney, meter reader; Bob Tipton, serviceman; Claude Spencer, lineman; and Jim Spaulding, office manager. (Courtesy of Irene Varain.)

The U.S. Forest Service controls a portion of Mariposa County. Claude McNally, driver, demonstrates early fire protection with Jerseydale's first fire truck. Since 1910, much of the resource development in the county—including timber, mining, recreation, and summer livestock grazing—took place on federal land. As larger timber operations, which provided much of the manpower for lookouts and fire suppression, began to decline, responsibility for these efforts shifted to professional Forest Service crews.

Before television dominated family entertainment, community events took center stage. The Mariposa Lions Club hosted a number of winter talent shows with this cast of characters providing square dancing. The dancers are, from left to right, Ansel Michel, Fred Richards, Bob Curren, Harvey Bonnell, Bob Dollar, Mervyn Catamartori, Jack Kalp, and Stan Meline.

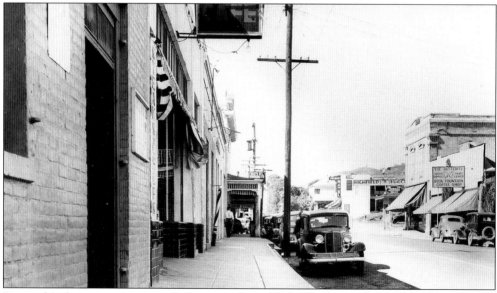

Pictured is downtown Mariposa looking north, c. 1937. The front of the Dulcich Building is visible (and yet to be improved). It housed the Butterfly Market, Restaurant, and Telephone Company. The Richfield Station sat at the corner of Sixth and Charles Streets, before it was closed during the war.

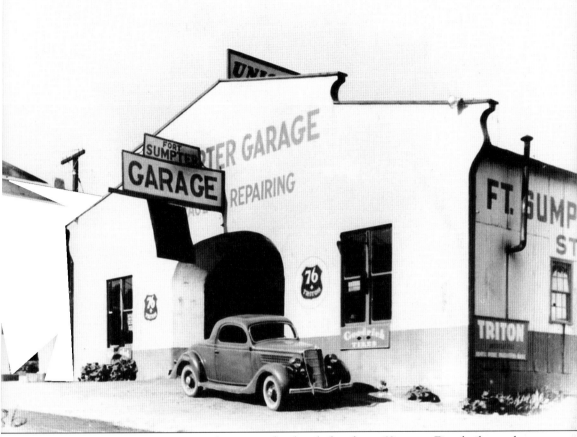

The Fort Sumpter Garage was a downtown landmark for about 60 years. First built on the foundation of a burned-out store, the shop stayed open under various owners and operators. Herman Schlageter started it and leased it to Ott Abbott. At some time, John Grosjean sold Chevrolets here, just across the street from McElligott Brothers Ford Agency. Grosjean also sold cars from his office in his family's building at the corner of Sixth and Charles Streets. He parked his inventory on the street. Abbott was succeeded by Ruth and Ernie Womack. The Womacks ran the garage and towing service as a husband-and-wife team. Ruth pumped the gas and kept the books, while Ernie built the tow trucks out of old Pierce Arrow schoolbuses that he had once driven for the high school. The old basement served as a grease pit. When Ernie passed away, the garage was leased to Al and Elinor Croft, who subletted upon Al's death to Robbie Graham. Eventually, the building was replaced by the new Bank of America, then a savings and loan, and finally a ladies' wear shop. (Courtesy of Nancy Radanovich Strathern.)

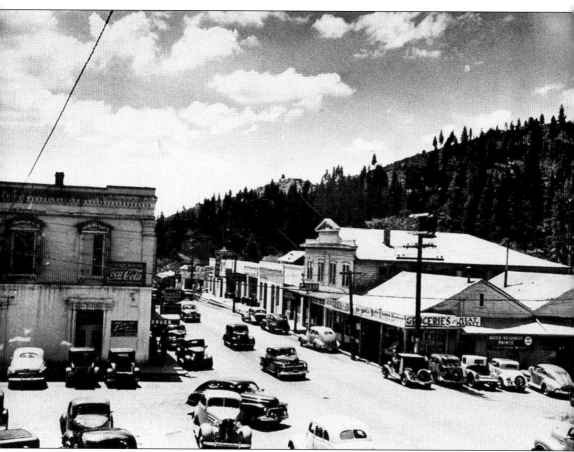

This postcard photo shows downtown Mariposa, *c.* 1948. The Mariposa Drug Company was then owned by Roy and Alberta Radanovich, as was the vacant lot in the foreground, which was once the home of the Richfield Station. By 1959, the Radanovich family constructed a new store on the gas station lot, and George Radanovich moved his men's clothing store into the old IOOF building, where it is still operated by son Michael. Note the mixture of pre- and postwar automobiles and the Zenith sign on the drugstore. Little change has taken place in the buildings, save for the restoration of the porch roof at the IOOF building and a bit of paint here and there. (Photo by Roy Radanovich.)

Here is Mariposa as seen from the south, *c.* 1950. Highway 49 ends at Mariposa. The road south is Bootjack Road. Extension of the state highway to Oakhurst and Highway 41 did not occur until the late 1960s. Note the bulk fuel tanks and operations at the south end of town.

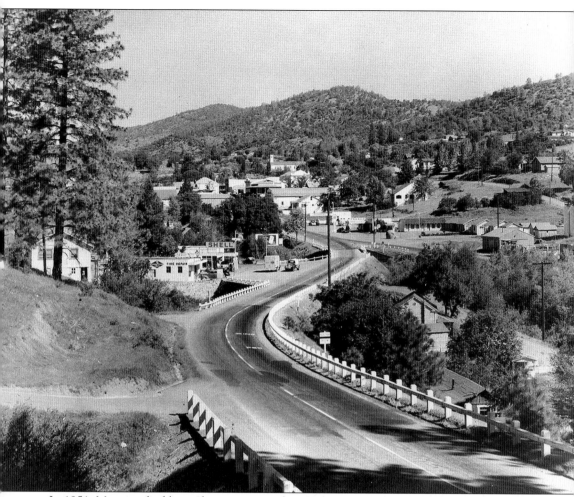

In 1951, Mariposa had been the county seat for 100 years. It was no longer a mining town, but had been reenergized by tourists, loggers, sawmills, and new chicken ranches and hog farmers. Returning servicemen and their families, along with those who left to work in war industries of the San Francisco Bay Area, brought new life to the county. Many changes took place after World War II. Electricity was extended to rural areas, Mariposa Telephone expanded to include more of the county, and school populations grew. Modern medicine came to the county with the formation of the John C. Fremont Hospital District. The Mariposa Public Utility District provided safe, clean water. By 1998, the Saxton Creek Project brought water from the Merced River to satisfy a growing population. This project may turn out to be one of the high points of Mariposa history. It was a fulfillment of Fremont's dream for his mines, only it was for domestic use. Business grew with small lodging units in Mariposa, along the Merced River on Highway 140, and in Fish Camp ad Wawona. They were replaced by major hotels and motels, all contributing to the economic growth of the county. Although the county population is approaching 20,000, most of the growth has come without industrialization, leaving Mariposa County still one of California's most pristine.

Seven

THE MT. GAINES MINE

The colorful mining districts west of the Fremont Grant included the Jenny Lind, Number Nine, Washington, Ruth Pierce, and Mt. Gaines Mine. All, at one time or another, supported many families. Mining began in the area with placering at Quartzburg and along Burns Creek. Due to lack of water, the miners soon went underground to search out the veins of gold. The first community to develop was Quartzburg, although a group of Mexicans were living along Burns Creek at a place called Hornitos. While the Quartzburg residents wanted to rid themselves of the "rough element," it was Hornitos that survived and grew into an important center. Quartzburg declined and faded away.

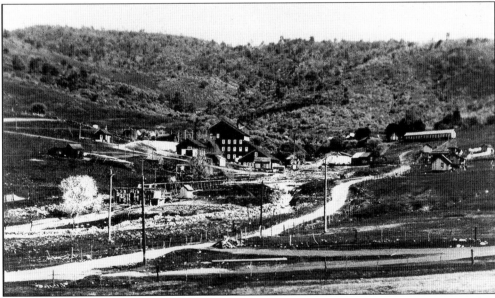

The Mt. Gaines survived into the late 20th century, consistently operating during most of its useful life and giving sustenance to the community of Hornitos. The mine-closing order of World War II did not affect the Mt. Gaines because it produced a material necessary to the war effort. The machinery was not scrapped for metal, as most Mother Lode mines had been. In the late 1970s, the author was able to photograph the above-ground workings of the mine, before they were removed and sold. While most of it had not functioned for many years, from these photographs one can get an idea of the environment of a historic gold mine. Unless otherwise noted, all photographs in this chapter were photographed by and appear courtesy of the author.

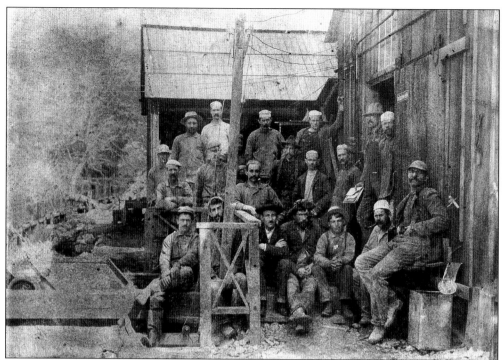

Pictured c. 1900 are Mt. Gaines Mine workers. The mine was a complete community unto itself, with a school and boarding provided for those holding responsible positions. The mine was a steady producer of gold and tungsten over the years, and the consistency of operations kept families in the area for many years. (Courtesy of Zora Wommack.)

One of the trucks that hauled concentrates and materials rests in front of the south half of the old mill building.

The head frame and crushing tower is the heart of moving the ore to the mill. Ore buckets were raised up the shaft to the top of the tower, then dumped into a grizzly that separated large from small pieces. Larger pieces went into the rock crusher and onto the stamp mill via conveyor belt. At this mine, there was a large amount of hand separation, thus a large waste pile is formed. This rock pile waits for further reduction.

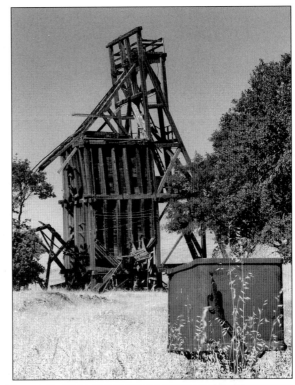

The ore buckets and the miners were raised and lowered into the main shaft by a powerful wench, operated by a single lever (just right of center in this photo). Electric motors one story down drove the hoist. On the right and in the back was the dial that gave the operator an indication of the depth of his ore bucket.

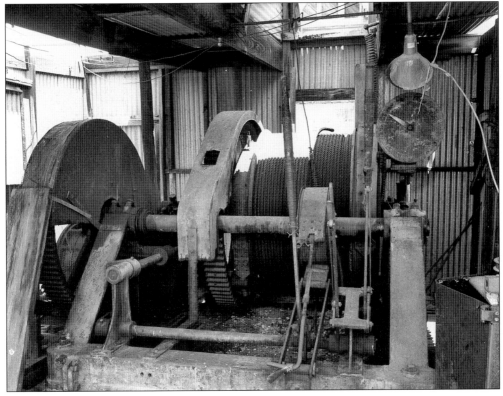

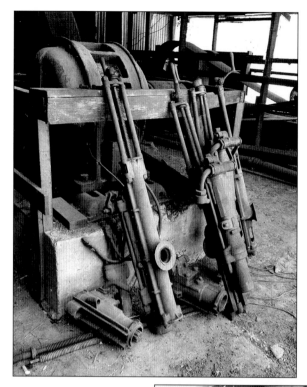

Drilling was done with compressed air drills. Steel bits were used, and the bit was gradually pressed into the rock by the screw jack at the operator's end of the drill. These drills were heavy, some weighing as much as 100 pounds. It took a strong man to put in 8 to 10 hours at the end of this machine, working by candlelight.

The separated and crushed ore was sent to the stamp mill for pounding into a fine powder. The hard gold was not crushed, but rather freed from the quartz and other rock, to be separated and claimed by various processes. This particular mill had four banks of five stamps each. The gold and quartz powder was washed across an amalgam plate of copper coated with mercury. There, the gold was held on the plates and its covering, and the fines moved onto a disposal pile called "mine tailings."

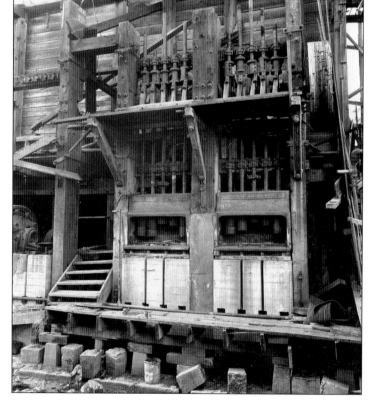

116

Pictured are the heads of the great compressors that provided air for the pneumatic drills and fresh air in the mine. Ingersol Rand was the principal manufacturer of the machines.

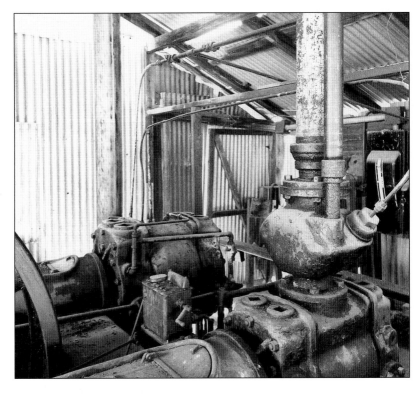

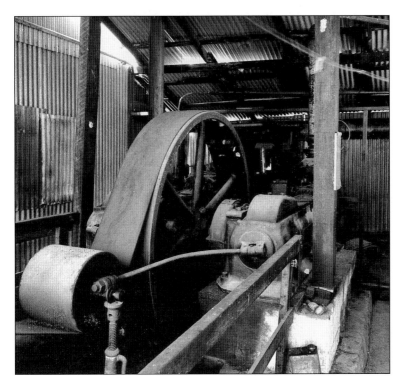

The great wheel that drove the compressor was in turn driven either by a steam engine or, as in this mine, by large electric motors. Note that in all these photos, there are no safeguards on any of the machines. The miners went underground with very little protection from falling rocks and other hazards.

Though there was a shortage of water on the surface, underground water plagued many miners. Pumping was constantly required. Cornish pumps were capable of lifting large volumes of water to the surface and are responsible for saving the California mining industry. After the arrival of electricity, pumps mounted on ore trucks were able to be moved to where they were needed throughout the mine complex.

Electric motors were used in many different ways at mines like Mt. Gaines. Here, the motors from the mill building and the separation tables are lined up, ready for sale. Both alternating and direct current was used—direct current because of the low danger of sparks causing gas fires in the mines, and alternating because of the higher horsepower.

An alternating current motor runs a direct current generator that created current for the assay office of the mine. Direct current was thought to give the higher temperatures needed to melt gold and separate it from the concentrates that had been produced in the mine mill. An artistic miner created a leaded glass window for the room.

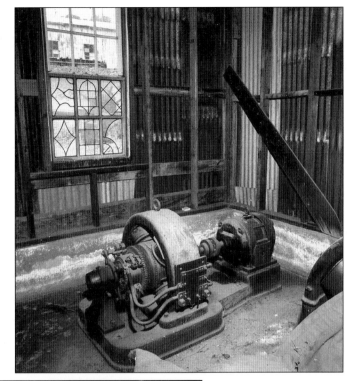

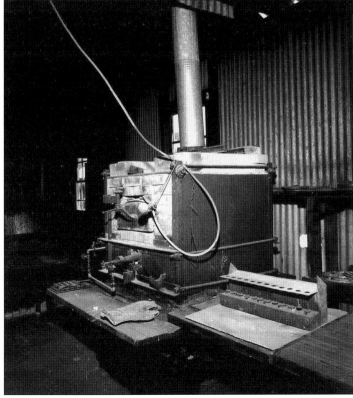

This high-temperature furnace was used to create small sample assays.

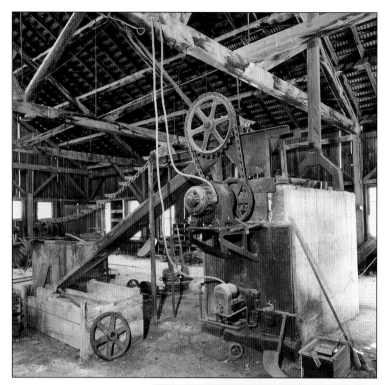

This gas- or oil-fed, high-pressure furnace was probably used for the blacksmith shop. As was typical in later 19th and early 20th century mines, the concentrated gold and minerals were shipped to smelters, usually in the San Francisco Bay Area, for further separation and purification.

The chemical storage room of the assay office contained the inventory of chemicals and crucibles needed for the assay function. The quantity of gold found in the ore that was developed in the mine determined where the miners would dig. Often, miners would find a particularly rich area and leave mere columns of rock holding up the ceiling. Their final act was to remove the pillars as they withdrew from the area.

Here is a workbench in the assay office that was used for pouring samples and evaluating composition.

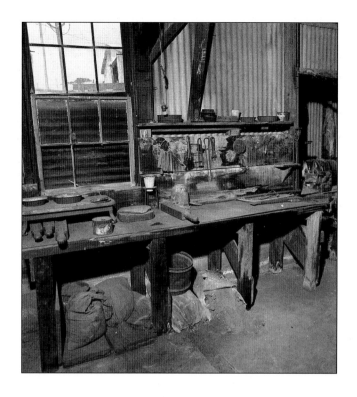

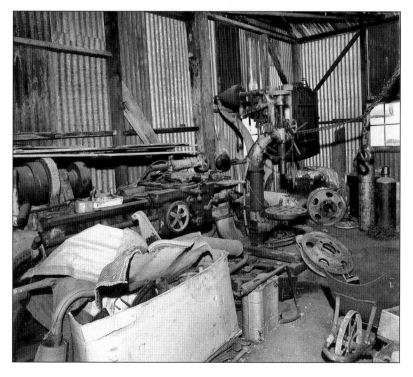

The mine's machine shop was a busy place. The large, horizontal lathe and vertical drill press were used by a blacksmith/machinist. The rough work of hard rock mining required many repairs to machinery and constant sharpening of drill bits.

Pictured is the chemist's work station in the assay office. Nothing about a mine seemed permanent. Frame walls covered with corrugated iron only provided some protection from the elements. The most comfortable place in the mine was underground, where the constant temperature provided relief from the winter's cold and summer heat.

This electric rotating drum, often called a trammel, was used to emulsify the gold and the mineral fines that made up the concentrate. Further refinement of the reduced gold ore took place in this device.

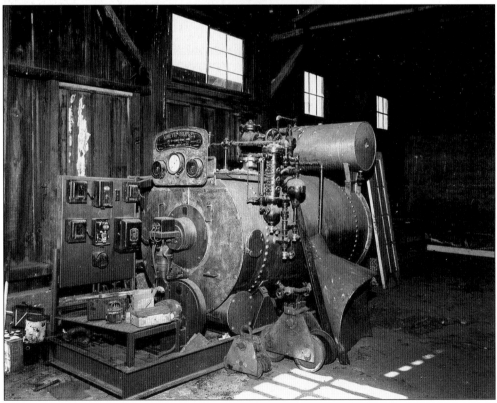

Underground equipment was operated by battery-powered machines. Some of the trucks and heavy surface equipment working at the mines also required large batteries, which required frequent service. This work station was constructed of wood because of the corrosive nature of the sulfuric acid involved.

High-grading, or stealing gold in one's clothing or pant cuffs, was always a problem. Miners were poorly paid and they felt little loyalty to the mine owners, who they felt were rich. Often, the mines were owned and/or financed by foreign investors toward whom nothing was felt. Miners had to change into work clothes in the room beside the showers and leave their clothes behind after a shift. The final inspection was done by showering the miners with water to recover any gold that might have stuck. The shower drains were also a recovery device.

The changing room at the Mt. Gaines Mine offered little privacy. An attempt was made to heat the room with an old boiler made into a wood stove, and to cool it with windows, but it was certainly not a pleasant building. Nonetheless, every underground worker had to pass through this room at the beginning and end of each shift.

Eight

HORNITOS AND JOAQUIN MURIETTA

It is unknown when the first camp was settled on Burns Creek. Perhaps they were Mexican, as evidenced by the fact that Hornitos was platted in the style of a Mexican village, its buildings surrounding a square with the town well at its center. When the first miners came to the area from the southern United States, they brought their slaves (or former slaves) with them. When California was admitted into the Union in September 1850, it was not a slave state. Black slaves were required to be freed by their owners or returned to the South. Moses Rogers came to California from Texas and worked with Col. Thomas Thorne at Quartzburg. It is not clear if he had ever been a slave, but he was an intelligent, ambitious man who quickly assumed positions of prominence. He soon became the superintendent of the Washington Mine north of Hornitos and perhaps a major investor. Over the years, Rogers invested in and controlled a number of mining projects and was included in a celebration honoring the pioneer miners of the area in the early 1900s.

Hornitos grew to become the only incorporated town in Mariposa County. Its name came from the *ornos*, or "little ovens," in which the Mexican women of the town baked their bread. Another story is that the name came from the above-ground graves made of brick, adobe, and stone. Examples of such gravesites may be seen in the cemetery of St. Catherine's Church. Tradition has it that in the summer, the clay soil was too hard to dig, and thus the dead were buried above ground in the "little ovens."

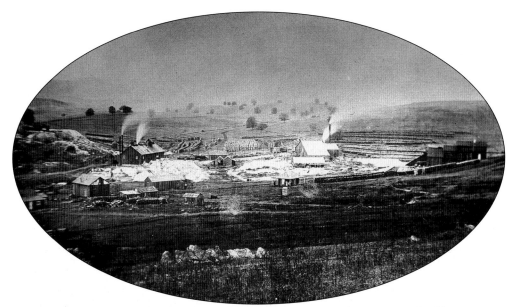

Pictured is a wide view of the Washington Mine in Hornitos. The mines in the Hornitos area were not included in the Fremont Grant, so they could operate without the legal entanglements that plagued such properties as the Princeton, Pine Tree, and Josephine. A branch or ledge of the Mother Lode seemed to run southwest, thus creating a rich mining area for the Mt. Gaines, Washington, Blue Moon, Jenny Lind, and Ruth Pierce Mines.

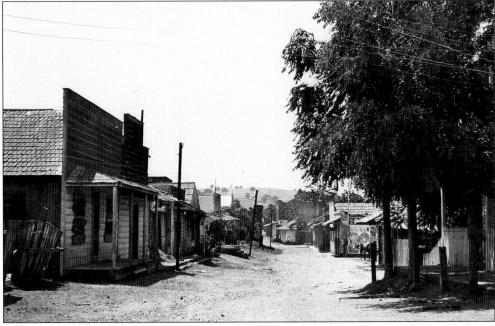

This c. 1917 image of Hornitos looks south down Main Street toward the plaza. Hornitos sported many bars and fandango halls and was known for its rowdy bunch. Many races lived in or near Hornitos, including Chinese, African-Americans, Mexicans, Italians, Germans, and Chileans. Today, Hornitos is a very quiet town surrounded by cattle ranches. The annual enchilada feed attracts almost as many visitors as ever once lived there.

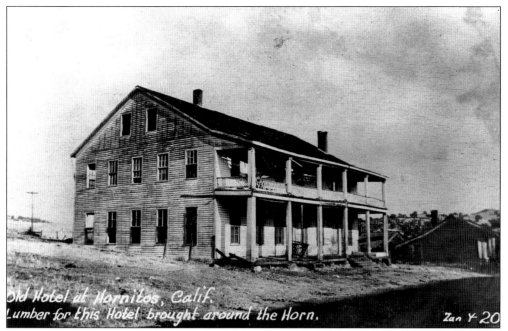

During the days of great mining activity, the three-story Hornitos Hotel was host to millionaires and even perhaps one president, Ulysses S. Grant. The hotel was constructed in 1858, from lumber brought around the tip of South America. It had a fine dining room and a parlor where "civilized" dances could be held, as opposed to the fandango halls found in the plaza.

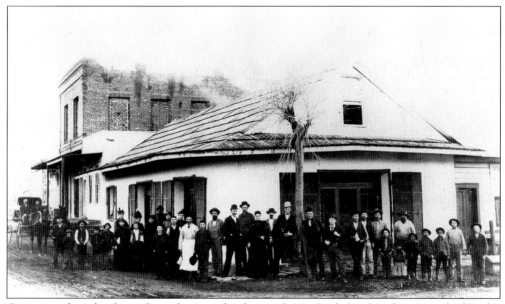

Citizens gathered to have their photograph taken with Mr. Reeb (in the white apron) of Reeb's Butcher Shop. Fights, shootings, and stabbings were the order of the day in Hornitos. Gold was easy to find, and gambling was a constant activity.

The two images on this page depict the public faces of Joaquin Murietta. Some described him as part Spanish with a Virginian mother of Anglo-Saxon background. His tour of revenge begins with the death of his young wife by self-inflicted wounds near Murphys, California. The senorita found her husband badly beaten and seemingly dead after an attack on their mining camp. Her brother was killed. Upon waking from his beating, Joaquin found his wife and brother-in-law dead, and vowed to find and kill those responsible. Thus set off a year-long spree between 1850 and 1851, of killing and looting of the miners who did him wrong. Hornitos became a favorite of Murietta for its beautiful, dark-eyed senoritas and its fandango halls.

Some saw the bandit Murietta as the wild-eyed robber and killer depicted here. He traveled the southern mines to avenge the deaths of his family members, and he assumed many names. Other bandits assumed his name too. Consequently, Murietta became wanted for many robberies and deaths throughout California, many of which he perhaps was not responsible for. The governor of Califoria formed a unit called the California Rangers to hunt him down and bring him to justice. In 1851, at Cantua Creek, near Coalinga, a man thought to be Murietta was caught and killed. He was beheaded and his head shown to many people who disagreed on the identity. The head was lost during the 1906 earthquake and fire in San Francisco, after it had taken up residence at the end of a bar in Hornitos for many years. The controversy continues.